# LEICESTERSHIRE
## PAST & PRESENT

# LEICESTERSHIRE
## PAST & PRESENT

### ROBIN JENKINS & JAMES RYAN

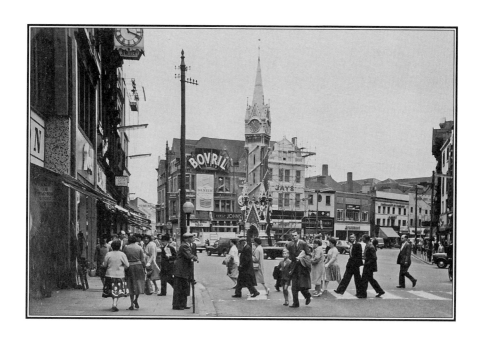

First published 2012

The History Press
The Mill, Brimscombe Port
Stroud, Gloucestershire, GL5 2QG
www.thehistorypress.co.uk

British Library Cataloguing in Publication Data.
A catalogue record for this book is available from the British
Library.

ISBN 978 0 7524 6515 9

Typesetting and origination by The History Press
Printed in Great Britain

# CONTENTS

# INTRODUCTION

This volume is the result of team work. The words, in the main, are those of Robin Jenkins and the photographic work largely that of James Ryan. The old photographs are all drawn from the rich resources of the Record Office for Leicestershire, Leicester and Rutland, supplemented from the collection of the Leicester City Museum (through the courtesy of Philip French) in the case of a few of the city images.

However, the team was broader than the two authors, whose names appear on the front cover. Jess Jenkins proved a vital as well as an agreeable companion on many a photographic expedition, providing a keen eye for the odd surviving chimney pot, or window frame.

We should acknowledge too our colleagues at the Record Office, past and present, whose careful custodianship has ensured the survival of the photographic treasures we have so gleefully plundered. It would be wrong, too, to neglect the staff at our publishers; especially the patient and long-suffering Michelle Tilling, without whom we would still be discussing our plans for a book.

Finally, we should also salute the photographers of the last century and a half. Without their diligence, ingenuity and eye for a good picture, we would all be very much the poorer. They may have been the cause of extraordinary amounts of trouble, frustration, and annoyance to us but they also have excited our admiration, amusement and wonder. We are pygmies in the shadows of giants; hopping from one massive footprint to another – but we have had an agreeable time of it!

One small volume can scarcely do justice to the rich photographic heritage of Leicestershire. Perhaps there will be other volumes but for now, we restrict ourselves to the larger market towns. These are the places best served by the photographers of the past and they are also those best known to locals and visitors alike. Even before the motor car, or motor bus, almost everyone would have been drawn into their nearest market town for some business or other. So, if your ancestor lived in Lubenham or Foxton, you may well see them here, wandering the streets of Market Harborough. You will also see what they saw, when they came to the market, or the fair.

Photographs are unique as an archive in that they are accessible to all. You don't even have to be able to read to derive use or pleasure from them. The more they are studied too, the more they yield. We have chosen our pictures with great care. They are all images that pleased us; which had a story to tell or which showed how little – or how much – life has changed.

We greatly enjoyed putting this survey together and we hope you will share in our pleasure. You can be assured that there is a great deal of joy to be had from the detective work comparisons of old and new require. We have had triumphs and disappointments. We have met some charming and helpful people and we have discussed them all over some very pleasant cups of tea.

*Robin Jenkins and James Ryan*
*Wigston Magna, 2012*

# 1

# ASHBY DE LA ZOUCH

Ashby was described in 1846 as 'handsome and highly salubrious' and it still is. The town has been through a number of transformations, from baronial stronghold, celebrated spa and watering place, to market town and regional centre. It has been a nest of brigands (as a key base on the frontier between King and Parliament during the Civil War) and a genteel Colditz – for Napoleonic prisoners of war.

The atmosphere of the town, as a result, is lively and surprisingly friendly. There is too much traffic (of course) but it keeps moving (or finds a parking place – which is rare in itself these days) and doesn't hinder the pedestrians, who have pelican crossings galore.

Ashby is a good place to visit. The castle is fascinating, the parish church filled with interest (and is open!) and the museum is a model of its type. There are plenty of places for your 'tea and a bun', as is usually the case with spa towns, and the people are smiling and friendly.

Photographers of the past seem to have concentrated on two areas in Ashby; the castle and Market Street. The castle has not changed at all (as far as we can tell) which is testimony to the care lavished upon it by English Heritage. We have therefore concentrated upon the broad thoroughfare of Market Street.

As you will see, there are few changes there, besides the odd, regrettable, modern intrusion and those fascinating details of altered costume, traffic and street furniture, which are revealed by careful study with a magnifying glass. There are very few photographs which do not repay (with dividends) careful study.

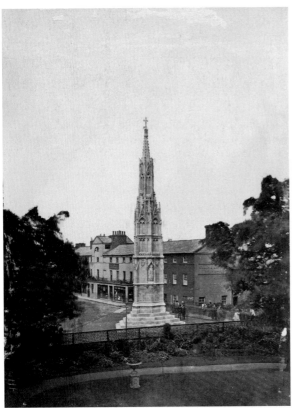

We shall commence our survey of Ashby in Bath Street, at the bottom of Market Street. Sadly, even though the view is largely unaltered, it is impossible to reproduce exactly. The garden, which was the photographer's viewpoint in the 1880s, is now fringed with obstructive evergreens. We have contented ourselves with a slightly different aspect, which nevertheless does permit comparison. The saline baths building has been extended to the south, while the Evans Rickards shop has made way for an undistinguished modern equivalent.

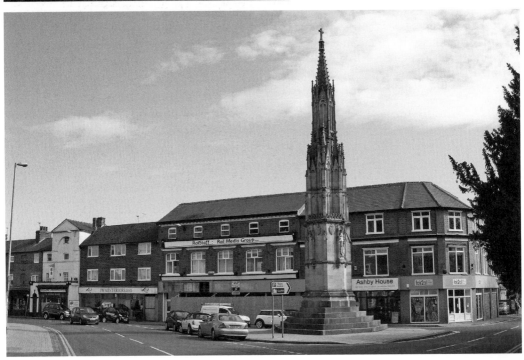

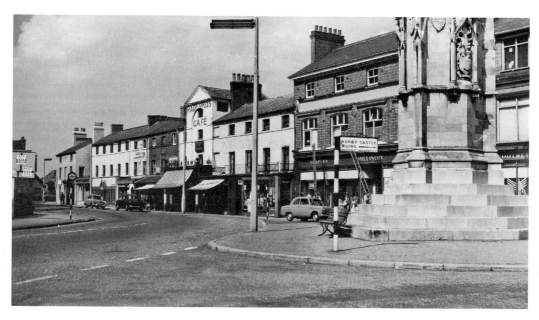

We have now skirted around the 1879 memorial by Sir Giles Gilbert Scott to the Countess of Loudoun to squint up Bath Street towards its junction with Market Street and Kilwardby Street. The atmosphere hasn't changed in fifty years. The buildings are like a row of teeth which have been capped, filled and polished. The smile is the same but updated; just like the shopfronts, the signs and the cars.

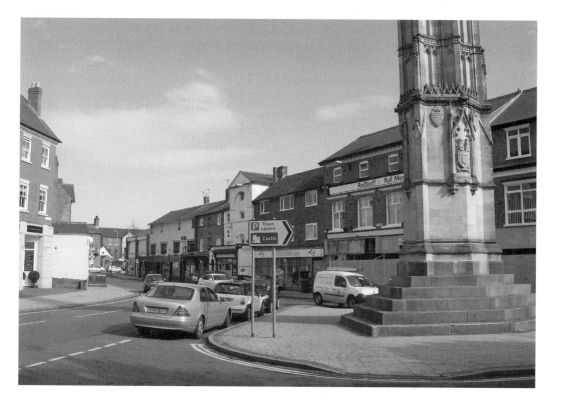

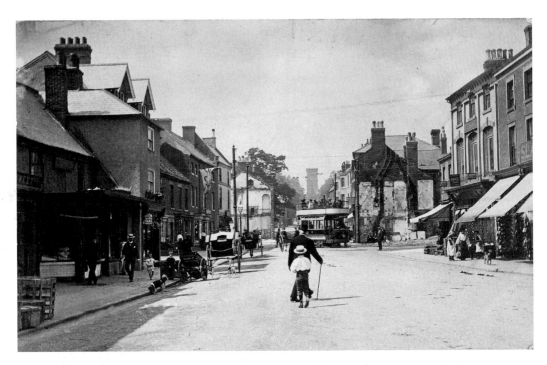

What an elegant place Ashby was! In our version of the view from Market Street towards the water tower, a local fire engine obligingly stands in for the Burton and Ashby Light Railway tramcar. The willingness of the old gentleman and straw-hatted child to stroll down the centre of the nineteenth-century road testifies to the increase in traffic since and explains the slight alteration in our viewpoint. We paused on a pedestrian crossing to capture the scene – to stand slightly higher up Market Street, where our forebear had, would have been suicidal!

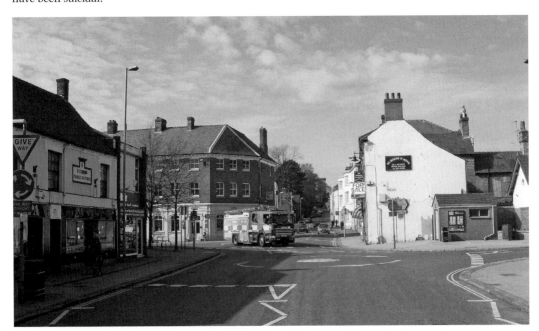

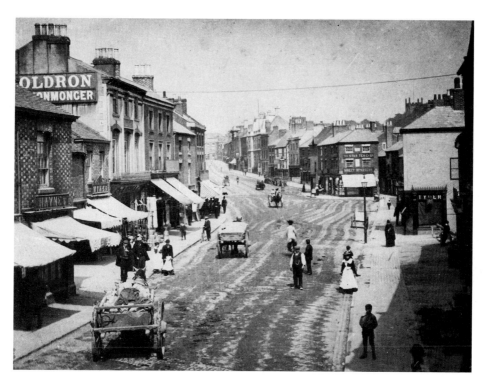

Our Ashby photographer of the 1880s once again eludes us – by taking to an upper room for his view of the market place. Little has changed. The traffic is heavier – but only very slightly, as the Victorian scene is filled with bicycles, traps and wagons – and there are new buildings to the left and new windows to the right. Ashby is bustling in both photographs but is there also an air of expectancy in the earlier view? Is something about to happen?

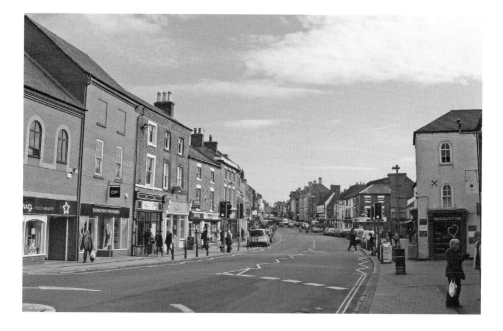

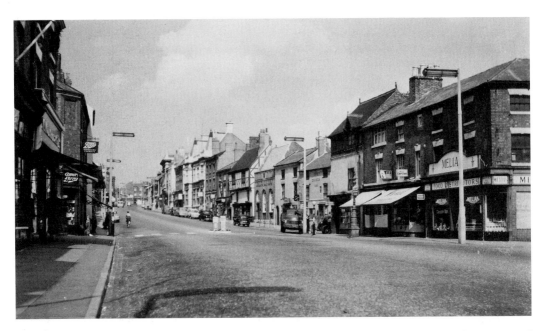

Despite the passage of more than fifty years, there are precious few differences between these views of Market Street and all are superficial. Ashby de la Zouch has done well to keep the developer at bay and to retain its market town charm despite tiresomely heavy traffic. It is still a town of independent shops and interesting buildings.

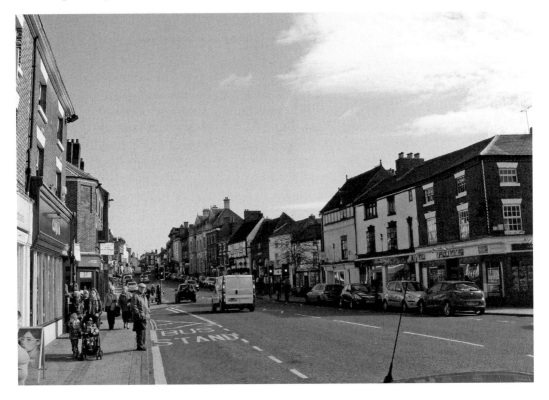

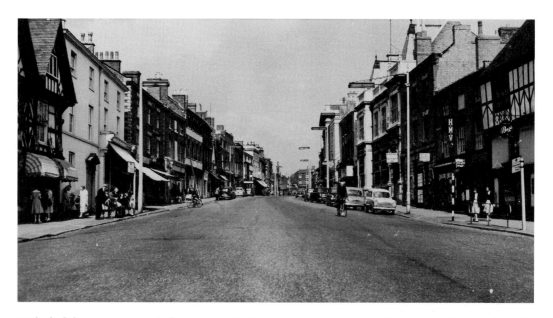

We lacked the iron nerve and all-encompassing insurance cover necessary to recapture this view from the 1960s. Even from the safety of the kerb (rather than the centre of the road) it is possible to see that traffic has wrought the most obvious changes to Ashby, with more cars and provision of white lines and parking bays to control them. Less obvious here is the square block breaking the roof line on the left.

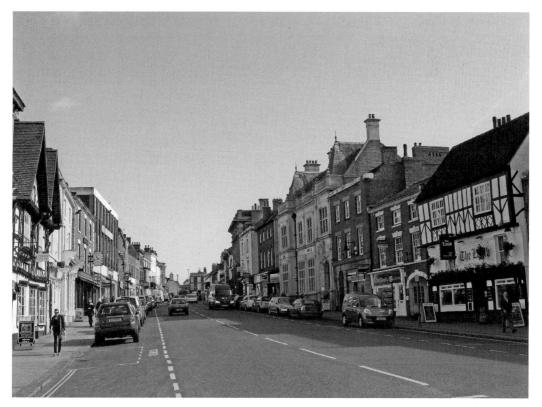

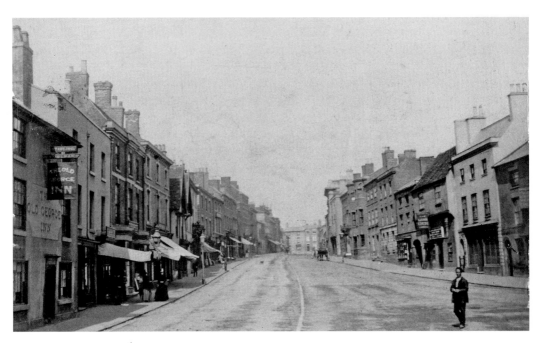

The George on the left of Market Street provides a useful anchor, as does the heavily pedimented market hall on the right. The earlier photograph, from the 1880s, shows the last days of Ashby as a coaching town; with its broad street dotted with 'watering holes'. The modern photograph shows how busy the town can be, while the earlier view is a mystery. Is it a Sunday? Why is the street so deserted? Sadly the shadows are not distinct enough to hint at the time of day, though the light is obviously good enough to provide such a clear photographic record.

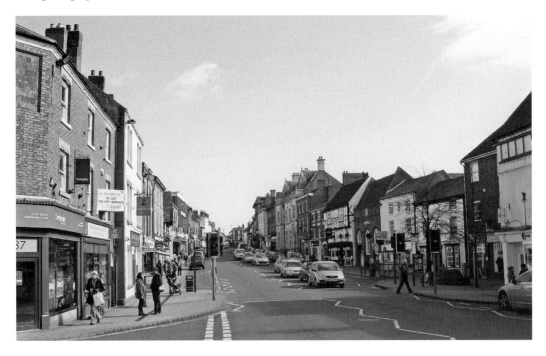

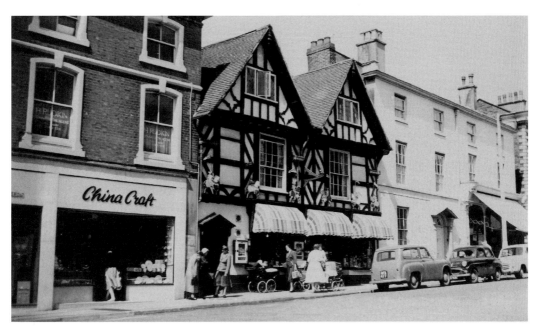

That the distinctive double gables of the half-timbered 'Elizabethan House' appeared clearly enough in our previous photograph is some evidence that its claim to antiquity might be justified. In fact there are more than a few sixteenth- or seventeenth-century timber-framed buildings in the street, concealed behind elegant Georgian façades. Little has changed in the sixty or so years since the earlier photograph was taken – except costumes and cars.

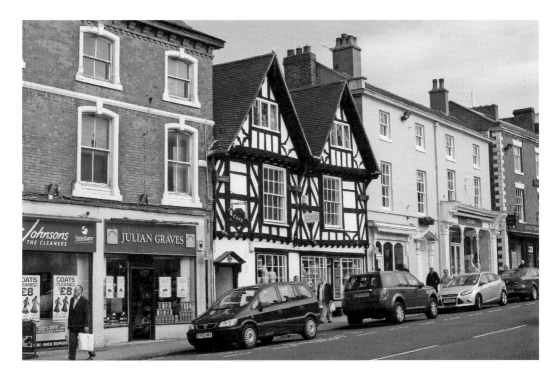

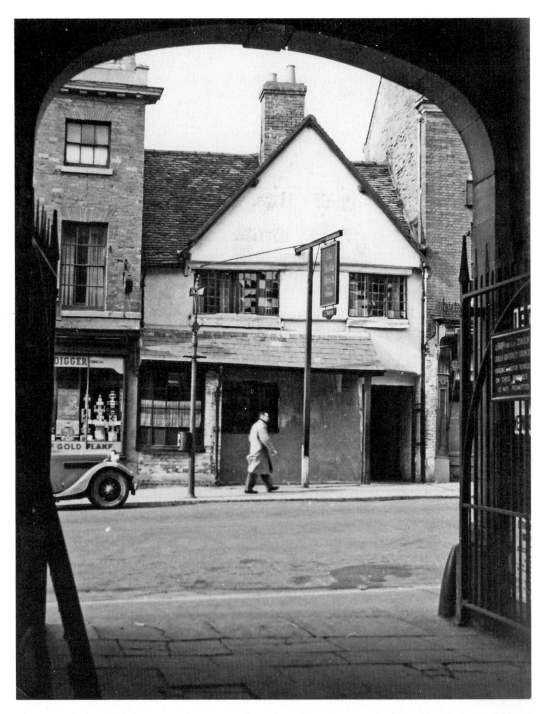

Now the perfect opportunity to stock up on apples and mushrooms, as we duck into the Market Hall (dated 1857) to photograph the Bull's Head (of nearer 1587). Not even the chimney pots have changed, though the tobacconist's next door has gone and the council has seen fit to hamper photography with an ironwork grille.

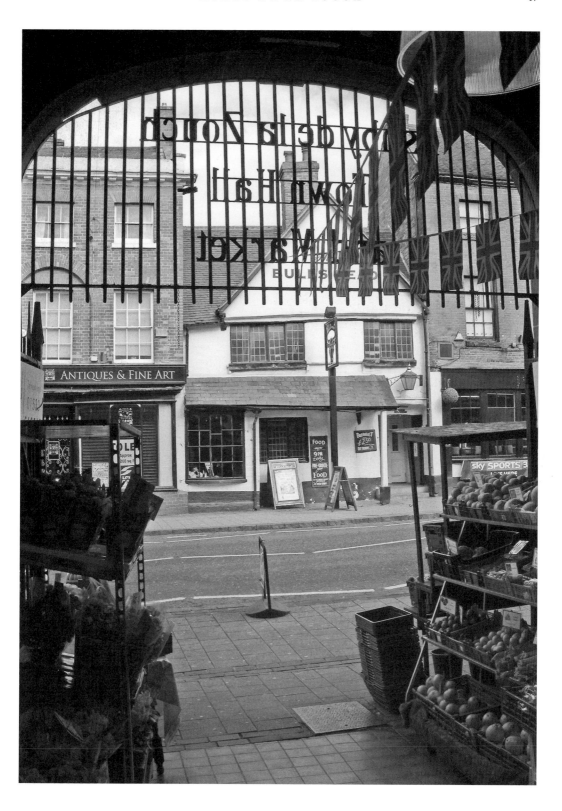

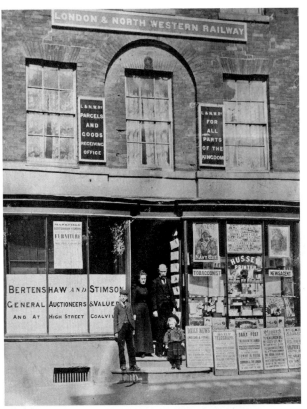

Little beyond the shop display has changed since Charles St Edmund Hussey stood on his doorstep, almost certainly in 1904 and 1905, to record his shop's expansion into the whole premises in Market Street. Our suggested date is supported by the newspaper adverts. Tibet was invaded in 1904 and Florence Maybrick, convicted in 1889 for the murder of her husband, was released after a campaign, in 1905. Hussey was an interesting character. He had been born at Mean Meer in India, shortly after the Mutiny. With him are his wife, Josephine (born in Bath), and two of his children – perhaps Bernard and Kathleen (both natives of Ashby).

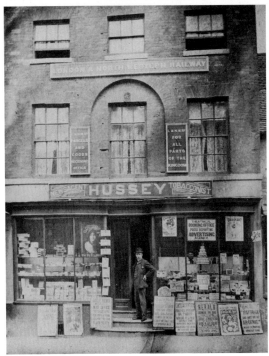

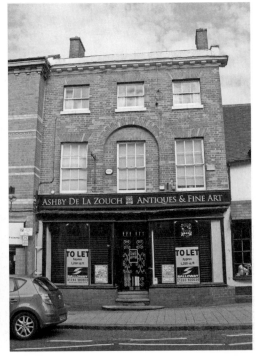

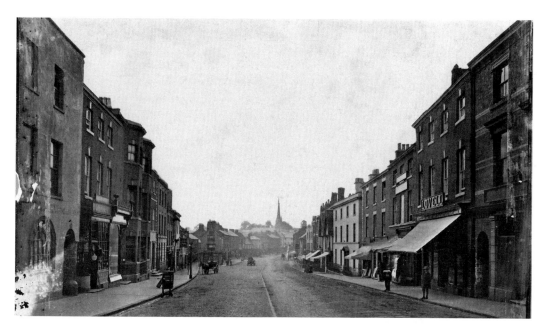

Having reached the brow of the hill, we must turn and look back down Market Street. The earlier photograph, dating from the 1880s, shows Holy Trinity Church still with its spire. Ashby is perhaps just waking up here – while in 2012 all is bustle and the traffic is heavy. New buildings have appeared on both sides of the street, though much has survived, especially around the block of buildings which now fill in one side of the market place.

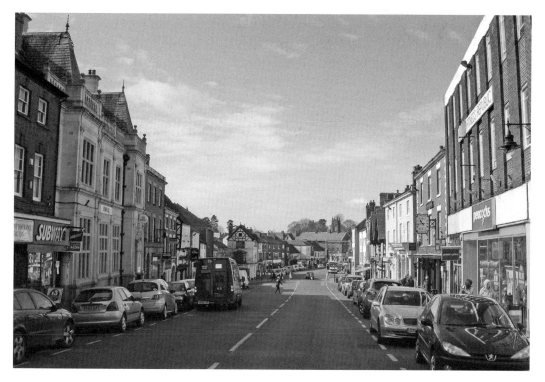

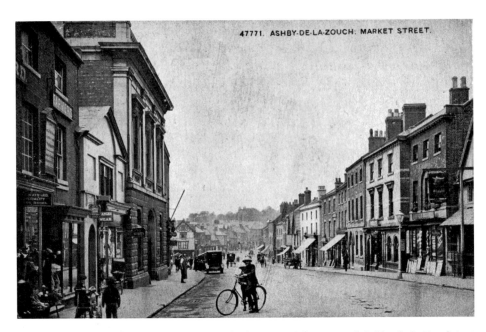

The arrival of traffic lights makes an exact duplication of this view of Ashby de la Zouch just before the First World War difficult. The photograph comes from a postcard of the town, printed by C.J. Lewis, of Market Street. The market hall is unchanged (the greengrocer still stands at its entrance) as are many of the shops on the right. The new block, occupied by Peacocks, jars a little – but only a little. In many ways, this is a view of Ashby on the eve of great changes. The motor car has arrived (and parked neatly on the left) but it is the first of millions to come. It is fortunate that so much of Ashby has survived and the town has not been destroyed by traffic – like so many other places.

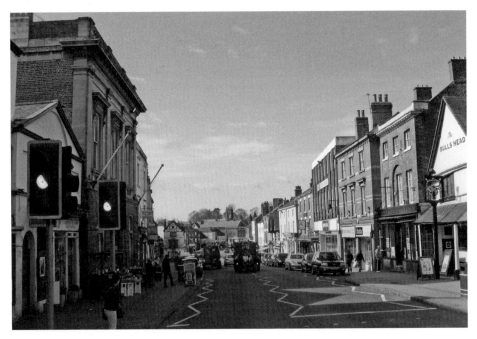

# 2

# HINCKLEY

Hinckley, it must be admitted, lacks the pageantry of Ashby or the faded gentility of Market Harborough and Melton. Even Elizabeth Williamson, updating Pevsner's guide declares that the town has 'few interesting buildings'. However, this is a verdict that has to be challenged. Hinckley is a busy, thriving place; business-like and bustling. The parish church and castle site are well worth visiting, as is the excellent museum.

Hinckley is a frame-work knitters' town, rather than one built to serve the gentry, and it can be proud of the fact. Developers have had their wicked way with the place (as they have everywhere) but the town still has a delightful confusion of little lanes and alleyways – which the inhabitants doubtless term 'jitties'.

Traffic is a trial, as it is everywhere and whenever we drive through we always get diverted or lost, with the confusing one-way system. It is easy enough to park there, though, and the traffic does move – which is a bonus!

As for comparisons between old and new, Hinckley proved one of the hardest of Leicestershire's market towns to deal with. Much has changed in the town centre and without the odd gable, chimney or even curve of the pavement, it is hard to be sure when there is a match.

Hinckley remains a challenge. We shall return, better armed with a range of maps, a compass and renewed determination!

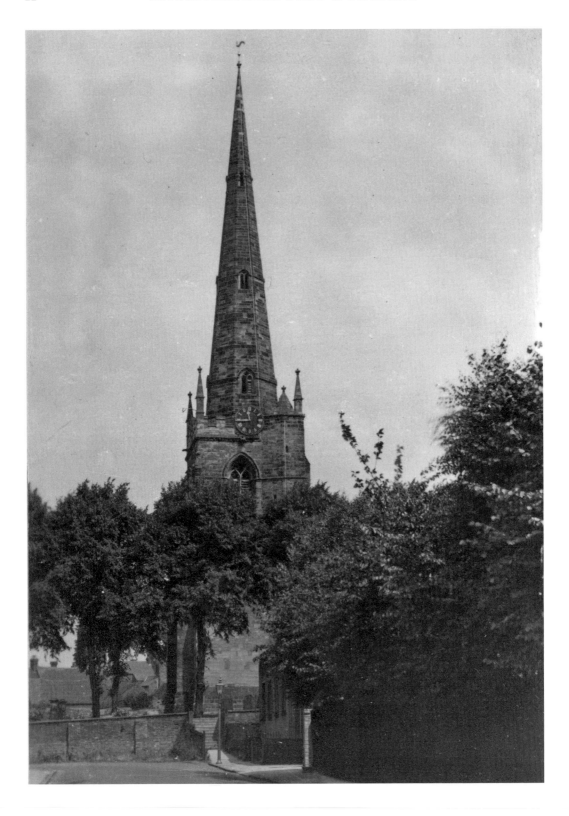

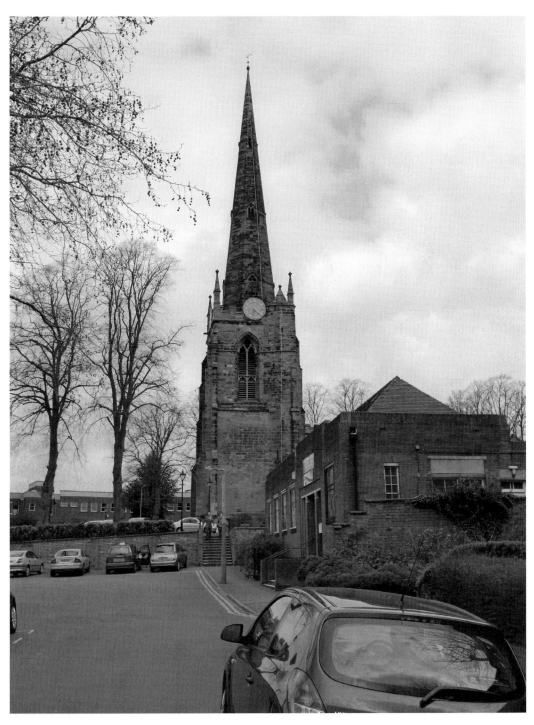

This is one of the few timeless views of Hinckley in our selection (despite the prominence of the church clock). The changes are largely superficial; trees have grown up and cars have been parked, but the spire of 1788 atop the church tower and the buttressed brick churchyard wall are still clearly visible.

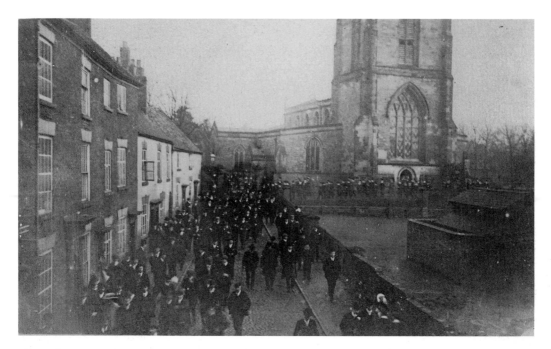

The earlier photograph of Church Street shows the congregation emerging from the Men's Service of 10 December 1905. Sadly we cannot duplicate the view from an upper window on the corner of the Market Place but the scene is easily recreated. The school playground to the right has changed with the times (thankfully no doubt for pupils wishing to use the toilets) while the columns and pediment around the doorway to the left survives, albeit in striking blue on white!

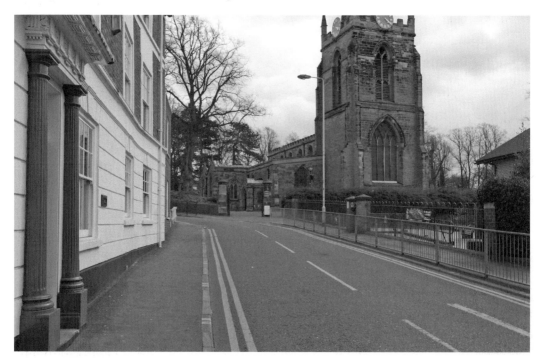

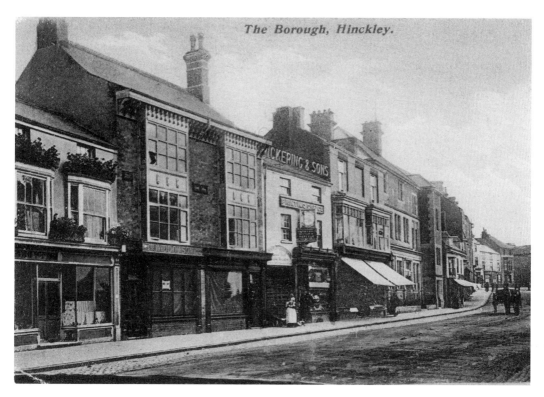

We can do little more here on The Borough than offer a flavour of the changes which have engulfed Hinckley. The earlier photograph, taken perhaps as early as the 1880s, shows the view looking southwards towards the Market Place. Our view (taken from a safer vantage point) looks the other way but demonstrates just as well how little has survived of mid-Victorian Hinckley.

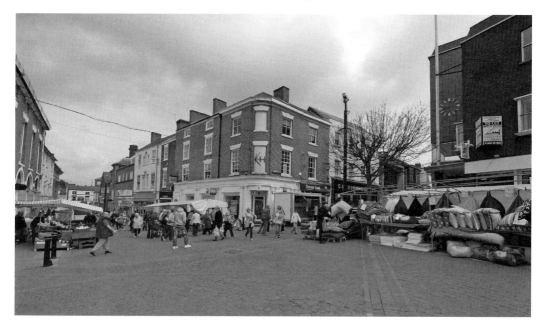

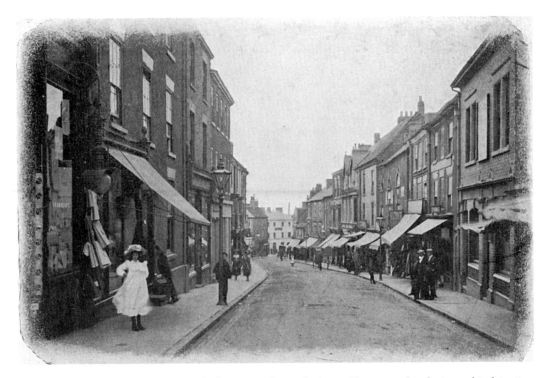

We shall turn now into Castle Street, which proves to be similarly troublesome to the photographic detective. The hustle and bustle is unchanged to be sure, but everything else seems to have been transformed. Even the pavement and roadway have been pedestrianised by infilling and levelling.

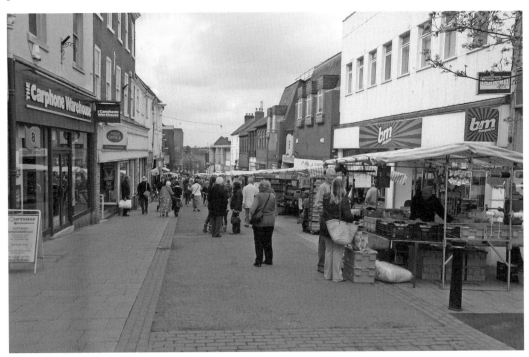

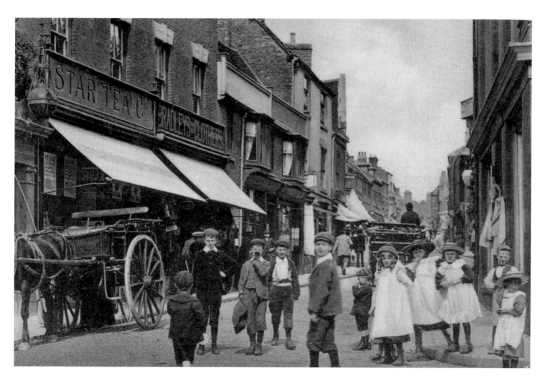

Our difficulties seem only to grow as we reach the highest point of Castle Street, where the Norman castle once had its curtain wall. Seemingly all the buildings are modern and defy comparison by the odd chimney, cornice or the arrangement of windows. It is intriguing that while in the 1890s the streets were filled with 'E. Nesbit' children, they are now peopled largely by older folk hunting bargains.

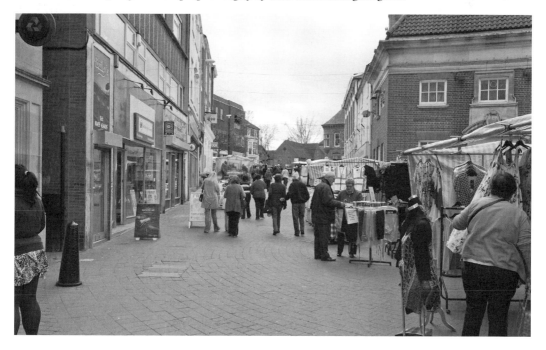

Fortunately, as we turn from Castle Street into the War Memorial Gardens, the scene becomes instantly more recognisable. Little has changed here in the last fifty or sixty years. The season is different, which means that less is obscured in our photograph by trees, so that the war memorial itself is visible on the right and more can be seen of the church and town behind. The ramparts which encircle the gardens may be the last vestige of Hinckley's castle, though it is just as likely that they represent landscaping for a formal garden in the eighteenth century. Perhaps they are both?

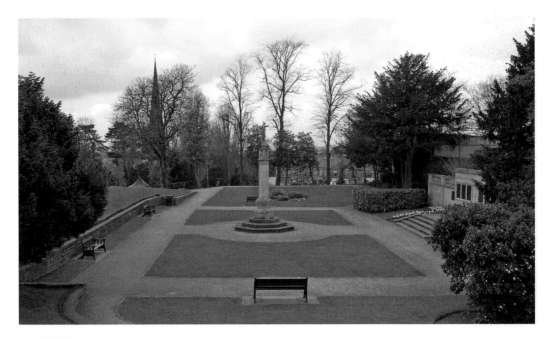

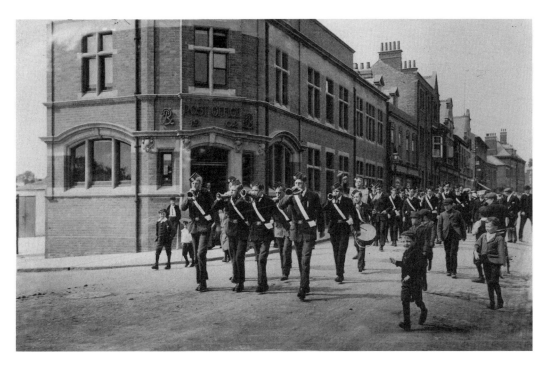

The post office at the junction of Lancaster Road and Station Road was barely four years old (and unextended) when our earliest photograph, of the St Mary's Church School festival parade, was taken on 28 July 1906. Once again, thankfully, the changes are slight or superficial. The post office sign and date has gone and traffic, with its parking bays and yellow lines, has appeared. Otherwise, all is recognisable.

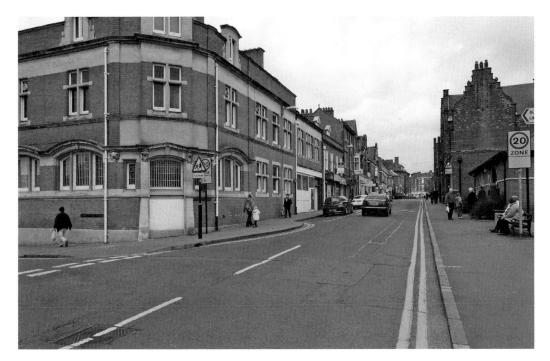

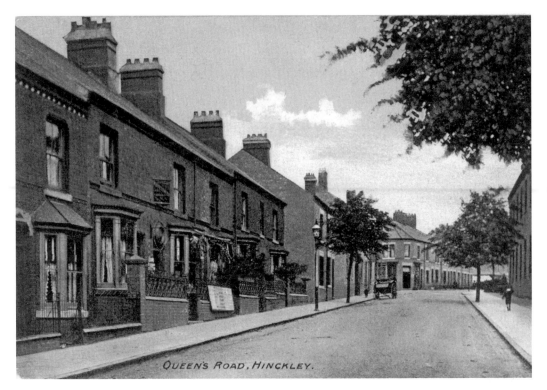

Who would have imagined, a century or so ago, that almost every resident in Queen's Road would have easy access to a motor car? Little else has changed. A few bay windows have been added to the terraces, some owners have opted for plaster rendering and satellite dishes have sprouted from upper floors. Otherwise, the buildings slumber on.

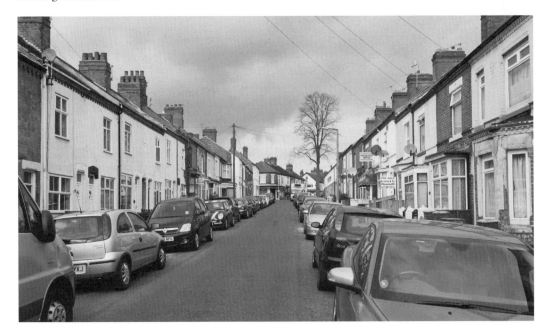

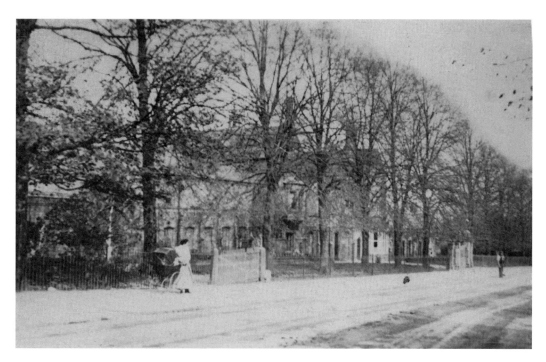

Here is a curiosity. In London Road it is the trees which are permanent, while all that is man-made changes. Who knows what Bloor Homes intend to do behind their screen?

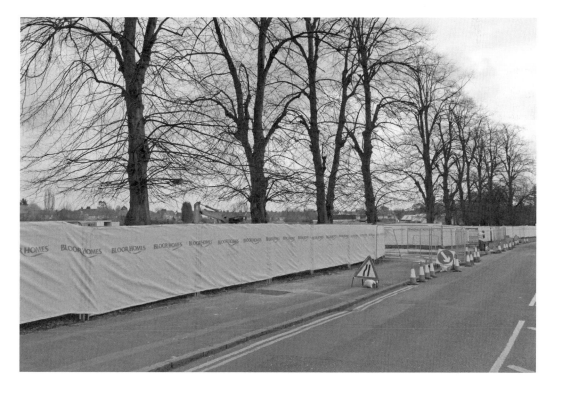

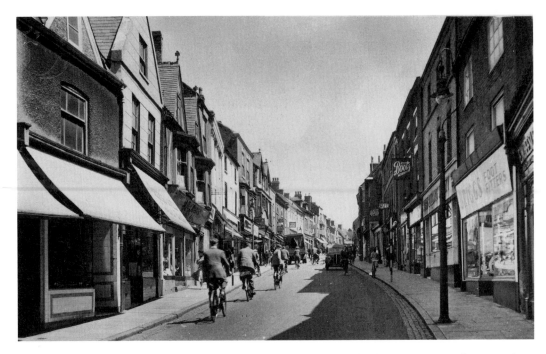

We are in Castle Street again. It is astonishing how much can change in half a century or so. The atmosphere hasn't altered, yet every other detail – of style, decoration, costume and habit – has been transformed. The gradient is no less but even the kerb has gone, with pedestrianisation.

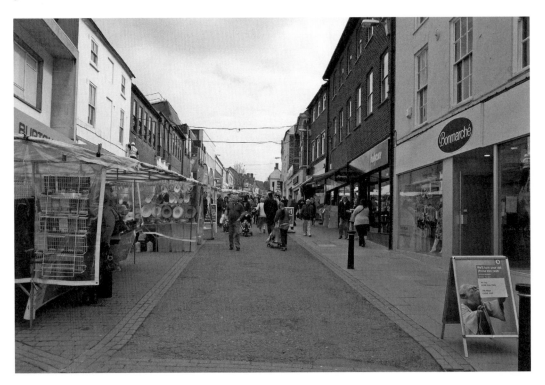

# 3

# LEICESTER CITY CENTRE

There are many reasons for the people of Leicester (and visitors too for that matter) to hold their heads up as they wander about the city centre. There are semi-naked ladies, fierce bearded Vikings, railway locomotives and even Nile paddle steamers to be seen just by raising your gaze above the shop windows of Granby Street and Gallowtree Gate. It is a largely Edwardian city which you will see, with all the elaborate architectural decoration that taste and cheap, skilled labour would permit.

Take a stroll around the centre of Leicester, keeping your eyes on the upper floors, and you will see what we mean. Leicester's centre is still in large part of the late nineteenth or early twentieth century. Our photographs will make this clear – as much by revealing shocking losses as by the general truth that so much has remained unchanged.

Leicester has always been a prosperous, somewhat inward-looking city. For a time it was believed to be the wealthiest settlement in the country, producing socks, boots, braces and even cigars for the Empire. The city centre still reflects that high-water mark on the eve of the First World War.

Leicester was a town that was proud of its past too. From time to time the borough made an effort to preserve its heritage of old buildings. The Roman Jewry Wall, a fourteenth-century guildhall and the Magazine Gateway were preserved, as well as a quartet of medieval churches and a few spectacular Roman mosaics. There were losses of course – many tragic or disgraceful. Even as late as the 1960s an inner ring-road was smashed through the city, severing ancient thoroughfares and bringing noise and petrol fumes to bewildered shoppers.

Thankfully, something of Leicester's historic heart was preserved from the dual carriageways and projected monorails. The twisting course of Church Gate and the narrow lanes of St Martin's still suggest their medieval forebears, while the backwater of The Newarke (once the 'New Work' of the Earl of Lancaster) provides a peaceful resort away from the crowds of the city and De Montfort University.

The variety of backdrops to the unchanging Clock Tower, recorded in hundreds of photographs, demonstrates how fickle fate can be in deciding which buildings should survive and which will be pounded to rubble by developers. The changing fortunes of the Haymarket illustrate too how often taste and common sense succumb to beguiling architectural drawings or a misguided desire for change and novelty.

Elsewhere, change is clearly for the better. Pedestrianisation, with its paved streets and new-planted trees must be better than lorries and cars. Slums and dirty factories have to go but must chimneys give way to grey concrete or 'Lego' tower-blocks? These contrasting photographs should be a warning for planners of the future; to note what works and lasts and to bear in mind how future generations will judge their efforts!

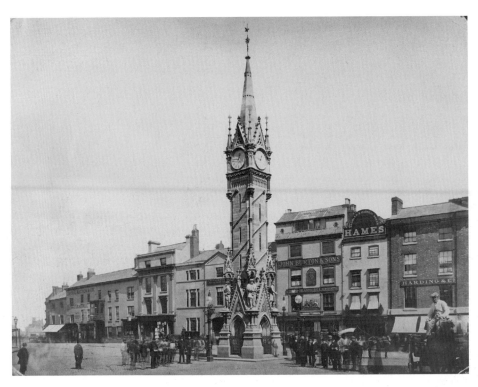

Leicester's Clock Tower has remained largely unchanged since 1868. It is therefore a photographer's dream for comparison purposes. Here we see the tower shortly after completion, with two top-hatted policemen to keep an eye on the curious crowd. The early photograph is almost certainly by John Burton, whose studio (with its specially lit upper storey) is visible behind – on the site now occupied by the Haymarket Centre. It was Burton who first suggested that a clock tower be built and Burton who laid its first stone.

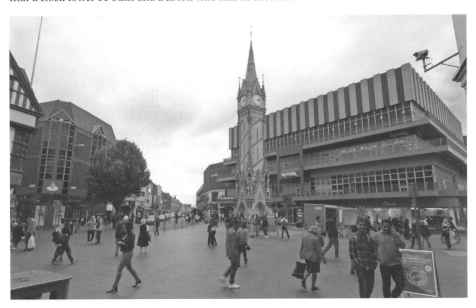

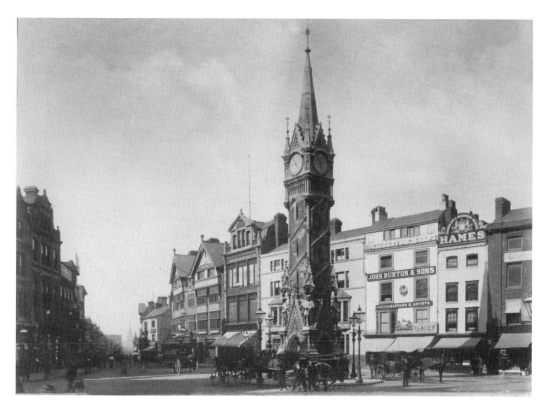

The next view of this angle of the Clock Tower shows it at the turn of the last century, before the arrival of the electric trams in 1904. Burton's studios and its neighbours still nestle behind, though newer, higher shops are advancing to the left, up the Haymarket from Belgrave Gate.

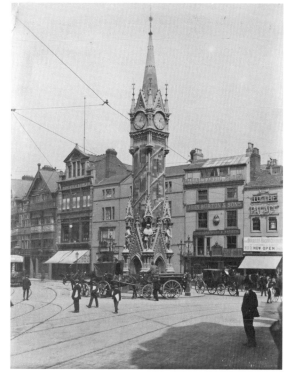

Once again Burton's shop appears beside the Clock Tower. We can date this photograph to late 1904 or early 1905. The trams' electric cables (of 1904) are strung overhead and the Danmark Bacon Company, a branch of James Nelson's butchery 'empire' (which appears in directories in 1905) has just arrived next door to the photographer. The photograph is not one of Burton's but rather comes from James Ramsden's Granby Street studio.

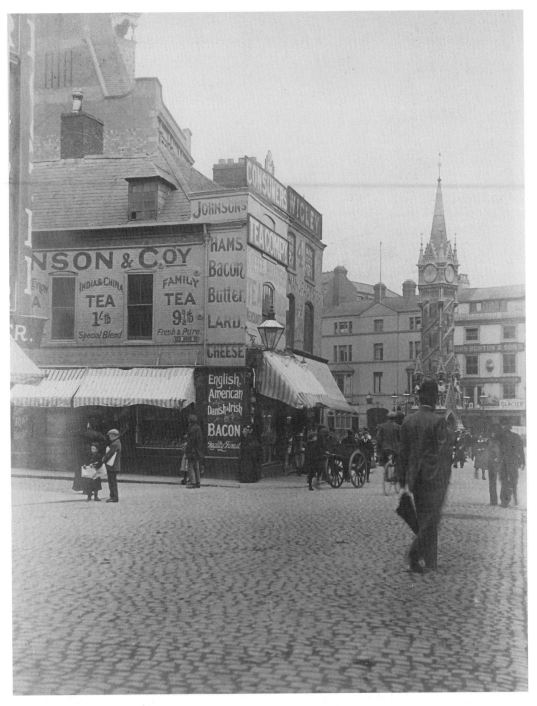

A view of the Clock Tower from the site of Leicester's ancient East Gate, *c.* 1900 and 2011. Although at first glance the Clock Tower stands like Dr Who's Tardis amid an alien landscape, in fact the central building of the left-hand row is largely unaltered – its elegant finials more prominent now than when they only just emerged from behind Johnson & Company's provision merchant's.

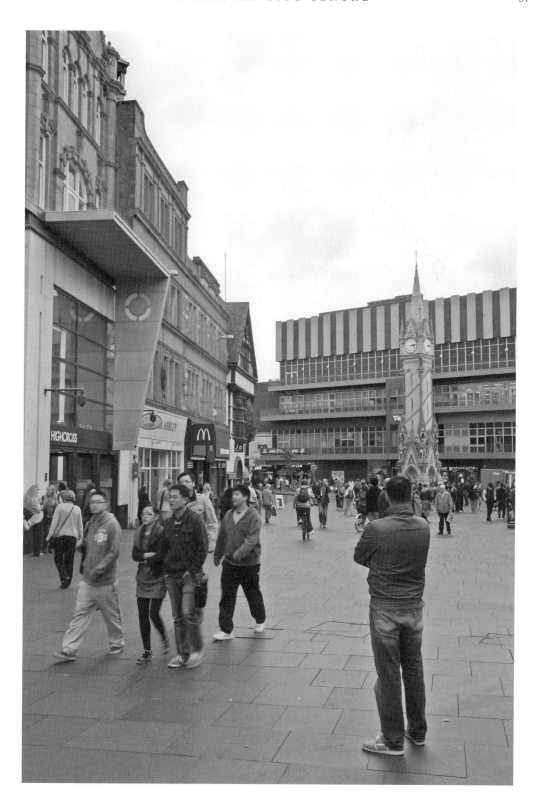

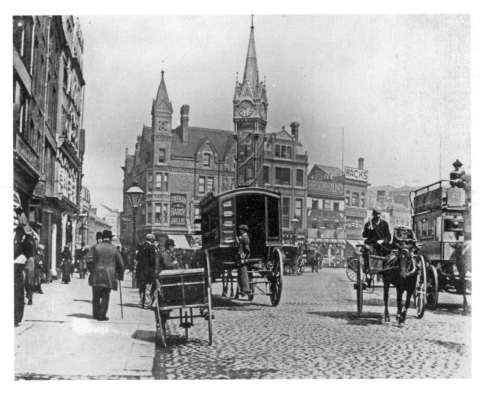

The Clock Tower has been photographed from every conceivable angle and approach. Here is the view from Gallowtree Gate. Only the building plots seem to have survived, preserving the size of shops rather than their form. Little of the 'spirit' of Leicester's town centre has changed – all is still rush and bustle and the utter absence of motor vehicles makes these two views strangely similar, despite their separation by more than a century.

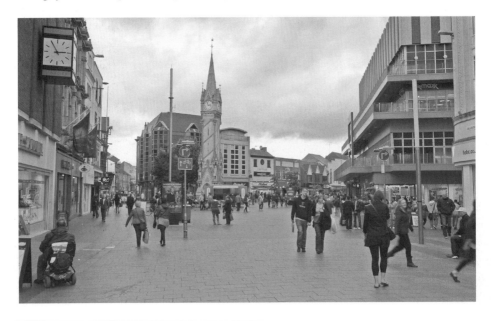

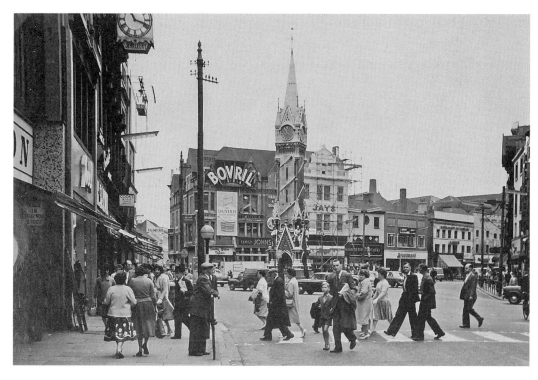

The array of familiar high street names make both these photographs valuable as a record of yesterday's and today's shopping habits. These views are thought-provoking. The zebra crossing has gone but then so has the traffic. Furthermore, why should it surprise us that it is the Leicester of 2012, rather than of fifty years earlier, which seems freer of litter and is there anything more English than a desire to promote BOVRIL in electric lights?

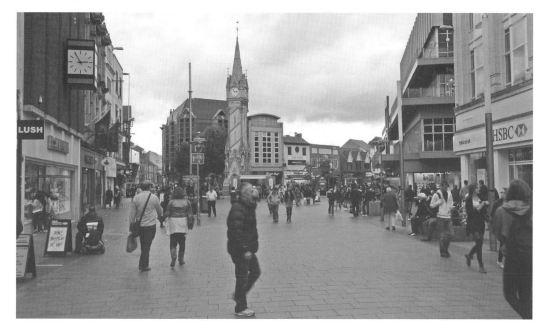

British Home Stores and Burton's may
no longer grace East Gates with their
presence but their buildings survive.
Intriguingly, the new premises to the right
of the Clock Tower still mirrors the shape
of the Clock Tower in its design, just as its
predecessor did in 1881.

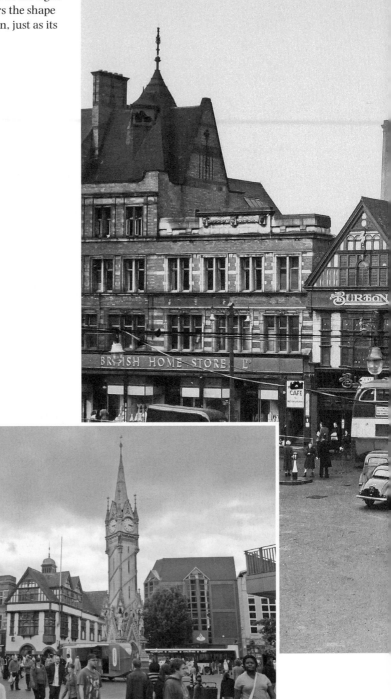

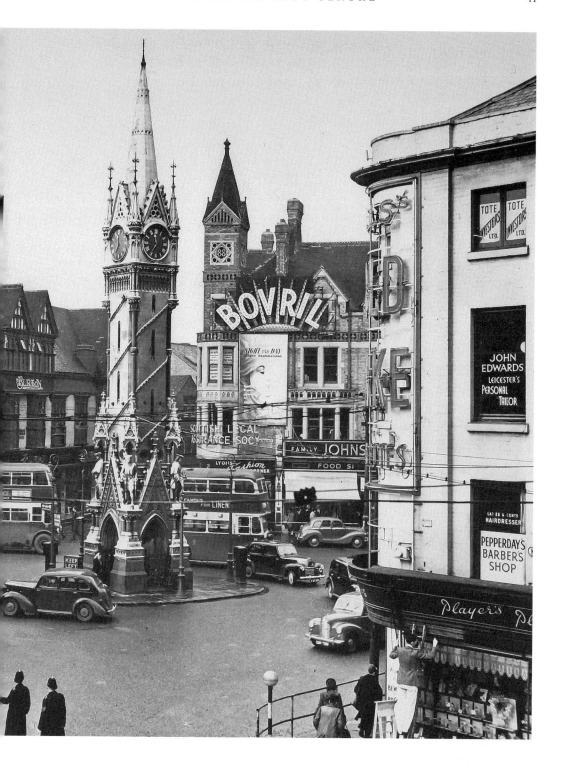

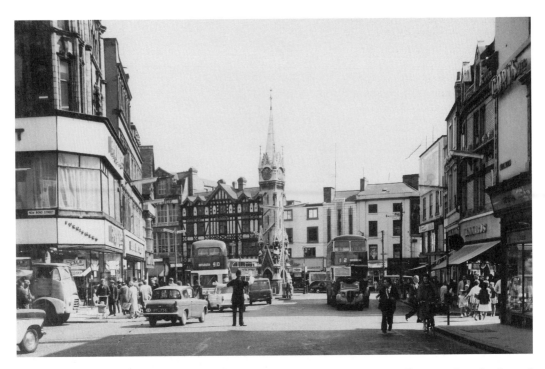

This approach to the Clock Tower, from the eastern end of the High Street, illustrates how haphazard destruction or survival can be. While the disappearance of New Bond Street and the Haymarket Centre's 'new' striped façade gives the impression of devastating losses; scrutiny of the upper floors on both sides of the East Gates tells a more hopeful story of survival and preservation. No doubt the stylish, rounded front of John Lewis's will one day look as dated as the furnishers it has replaced.

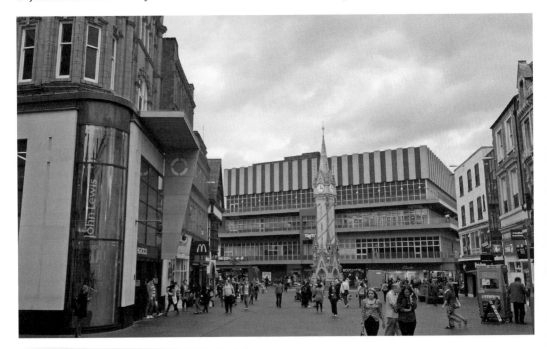

The Clock Tower without a backdrop! This photograph shows the early stages of the Haymarket Centre's construction between 1971 and 1973. It reveals a nondescript hinterland of brick offices and a single chimney – possibly that of Stead and Simpson's boot and shoe factory off Mansfield Street.

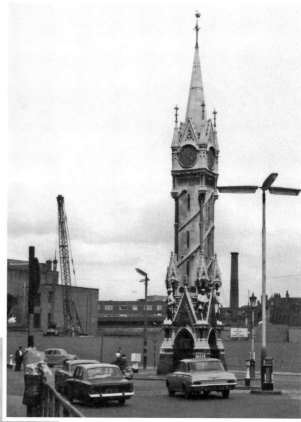

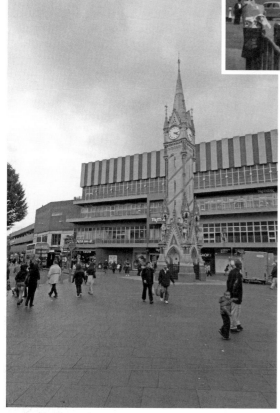

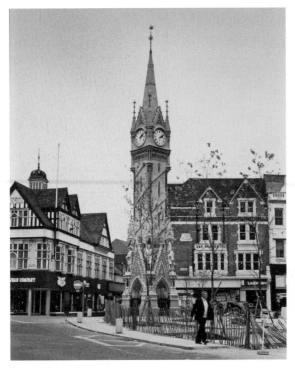

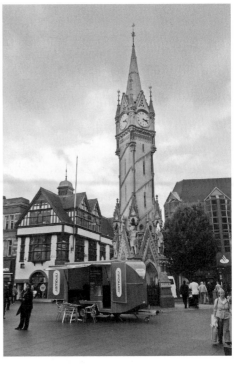

*Above:* It cannot have taken more than a few months for the Clock Tower to become a focal point for Leicester. How many trysts and rendezvous have Simon de Montfort, William Wyggeston, Thomas White and Gabriel Newton seen since 1868? Rarely too is the Clock Tower without some fencing or other impedimenta around it – as these photographs (from about 1975 and 2011 respectively) testify.

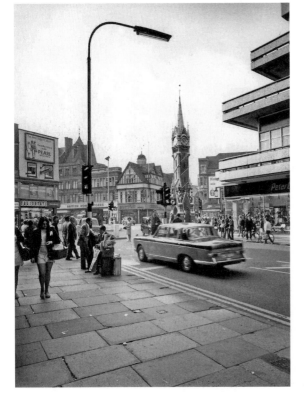

*Left:* A last view of the Clock Tower – by 1968 a century old. Life seems to be whizzing around the old lady, leaving her bewildered and out of place beside the new Haymarket Centre. The trams have gone and traffic lights have replaced the lone policeman, who has graced so many of our earlier photographs.

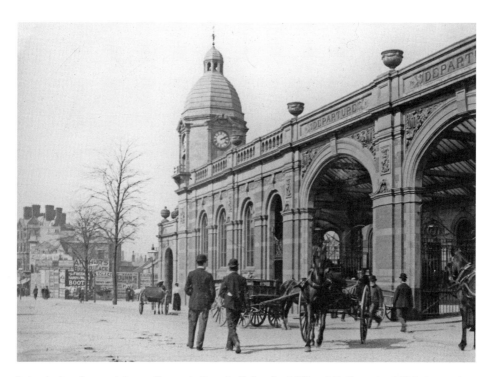

Leicester's sole surviving railway station, built by the Midland Railway in 1892, is another of the city's iconic buildings. Like the Clock Tower it seems to have survived untouched, while all around is changed. Beyond the domed turret are two of Leicester's 'skyscrapers'; one apparently made from Lego. Traffic seems always to have been heavy around the station, though its horsepower has increased somewhat.

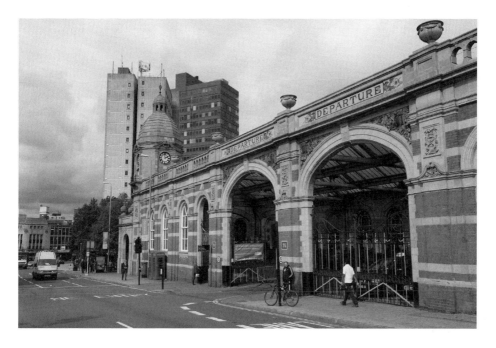

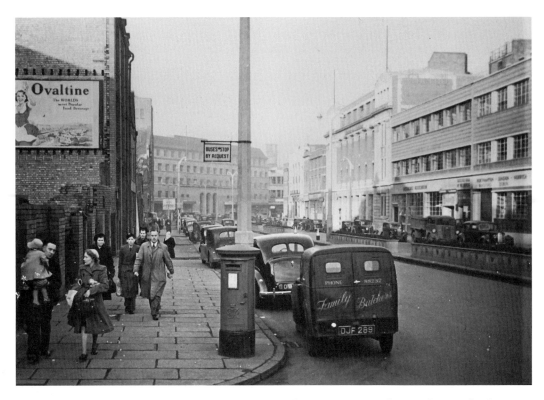

It is certainly a matter of all change at this late 1940s Charles Street bus stop. The grand 1930s development, which Leicester so justly celebrated in 1932, seems something of a backwater now; with cheap students' lodgings and boarded-up shop fronts. Even the pillar box has gone, presumably when the council remodelled the corner of Halford Street.

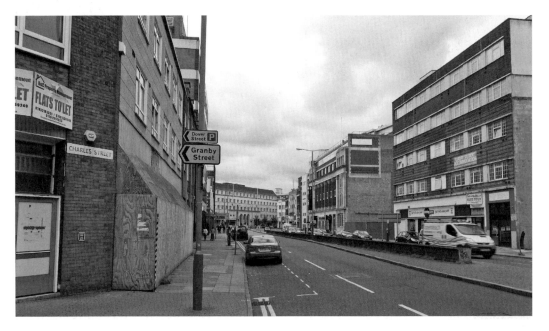

An apparent conspiracy of roadworks and trees make it almost impossible to duplicate this image of the Grand Hotel and Granby Street. In one of his typical outbursts, the architectural historian Nikolaus Pevsner brushed aside Cecil Ogden's 1897 design for Leicester's foremost hotel as 'of no architectural value'. It still dominates Granby Street, though, and draws the gaze of passers-by up and up.

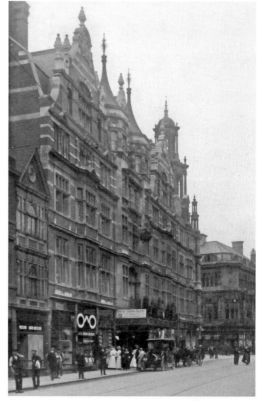

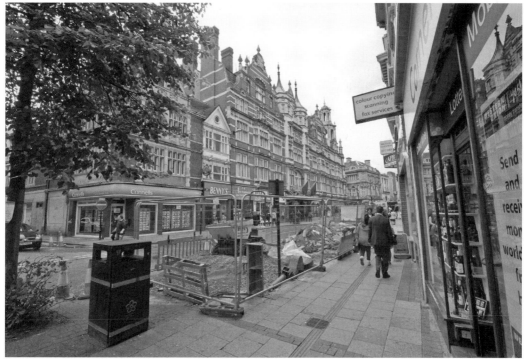

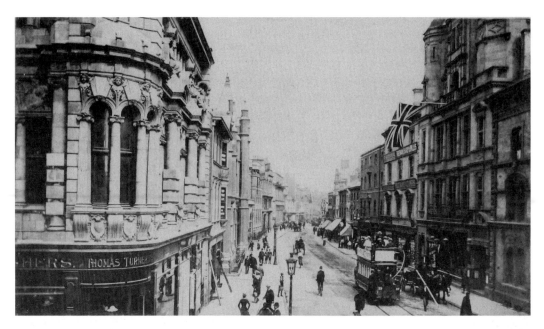

The pursuit of this Edwardian photographer's vantage point took us into the Grand Hotel, where (through the courtesy of the management and staff) we were able to reproduce almost exactly this view from high above Granby Street/Belvoir Street junction. Once again we see clearly how little has changed above street level. Flags are still flying over the road. Admittedly, though, in this Valentines view from about 1910, Sir Herbert Marshall's piano and music shop hoisted a patriotic Union flag, while in 2011 it was the Italian Tricolore.

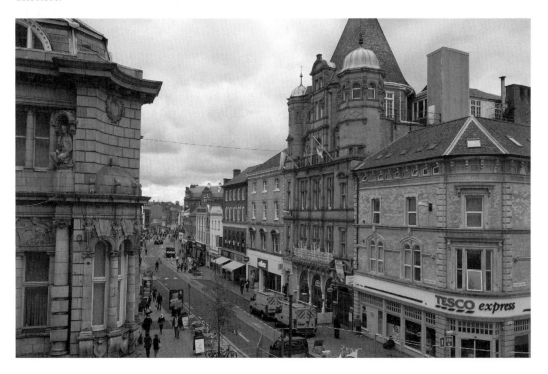

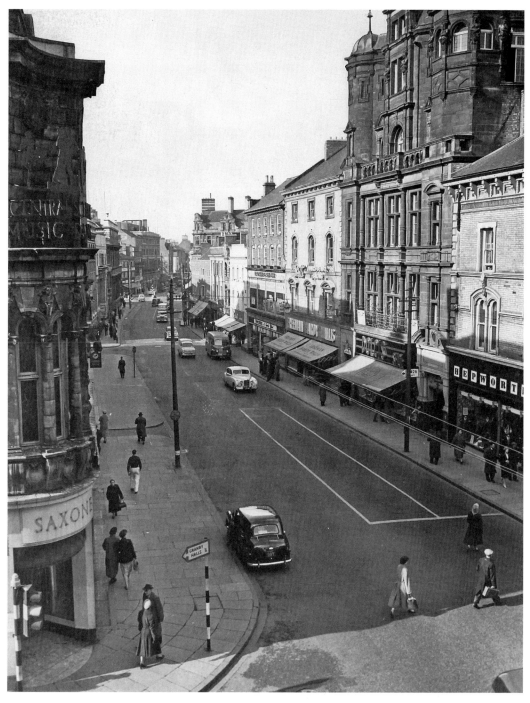

The same public room of the Grand Hotel was used again perhaps forty years later. The no. 37 tram no longer rattles along the street but Freeman, Hardy & Willis are still there, competing with Saxone and Dolcis, to make this a boot and shoe corner. The long overcoats and even longer shadows from the west suggest a bright winter afternoon – which might explain how quiet the street seems.

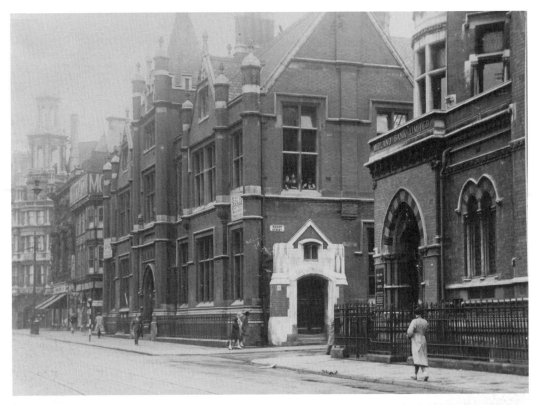

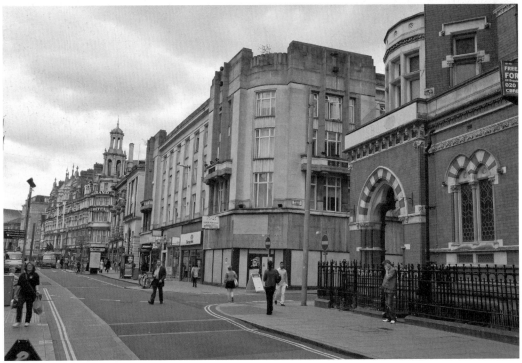

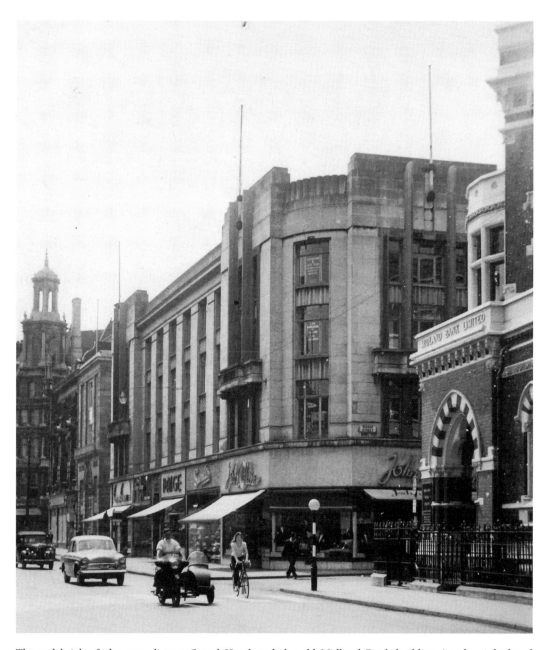

The red brick of the now-distant Grand Hotel and the old Midland Bank building (in the right-hand foreground) seems to stand the test of time better than the solid, grey 1930s block, which half a century ago housed 'the window to watch'. The red brick and white stonework bank was designed for the Leicestershire Bank by Joseph Goddard in 1872; four years after he produced the drawings for the Clock Tower.

*Opposite, top & bottom:* The three workmen gawping out of the old post office's window at the centre of this picture, some time in the mid-1930s, are probably engaged in its demolition. Within a year, the site would be a new office block, housing a 50 shilling tailor on the ground floor.

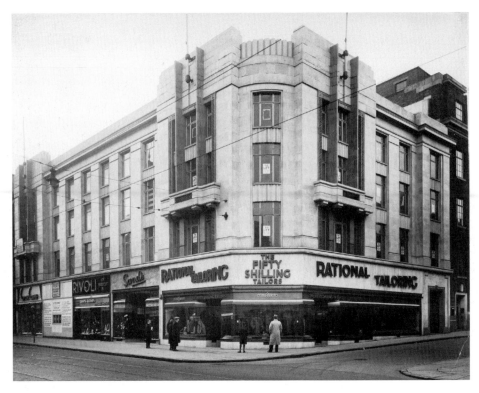

This pair of photographs, once again recording the corner of Granby Street and Bishop Street, shows how little changes in most of our town centre shopping streets. There is still a high turnover in tenancies and a good variety of small shops. The tramlines have disappeared in the sixty or so years since the first view was taken as has (sadly) the apparent interest of the passing public in 'rational tailoring'.

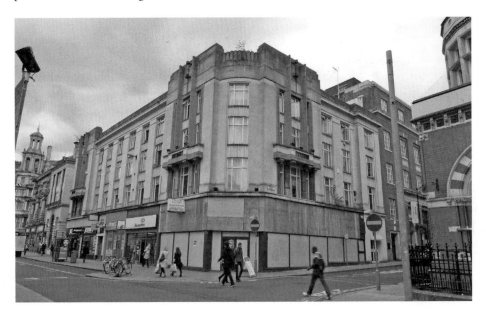

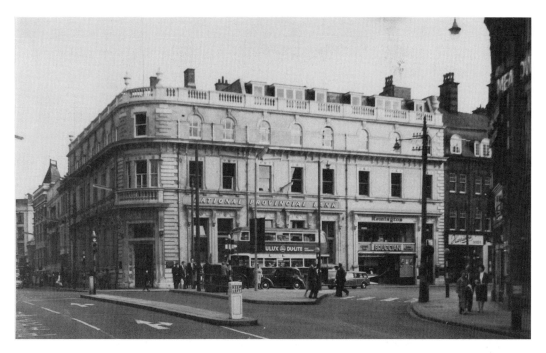

This view of Horsefair Street and Granby Street once again testifies to how superficial the changes in our towns can be. Little has changed architecturally. You can no longer sip your coffee in Brucciani's (though the Co-op will book you a trip to Venice instead) and no traffic emerges from Gallowtree Gate these days. Who in the 1960s would guess that fifty years on, a 'keep left' bollard would be replaced with a tree!

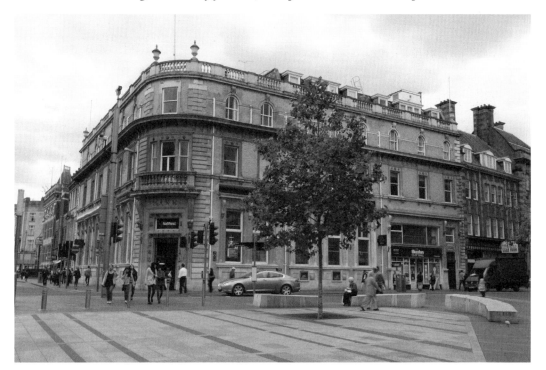

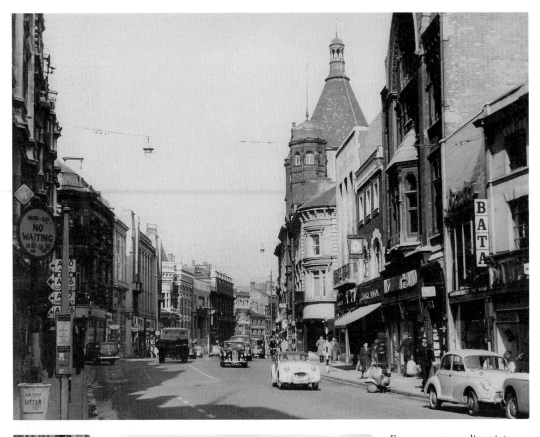

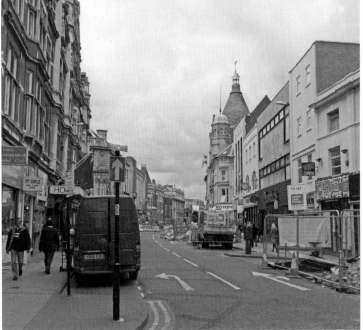

For once our earlier picture seems more cluttered than the later. The building work afflicting the modern Granby Street makes the comparison unfair but we would almost be tempted to say that the Leicester of 2011 has less traffic and even fewer instructions for the motorist than in the photograph of half a century before. The Leicester of the 1960s is certainly already a bustling modern city; with one-way traffic and parking problems only a few years away.

The older photograph here is of a fairly well-known Leicester character, 'Muggy Buns', selling his wares on Cheapside in the 1890s. Behind him are East Gates and New Bond Street. It is hard to recapture the scene, although the bustling market atmosphere hasn't changed at all. Were he to travel a century and more forward in time, 'Muggy' would recognise only the upper floors of one building – the Carphone Warehouse (though he might be puzzled to explain its purpose!) – and what would he make of the disappearance of New Bond Street?

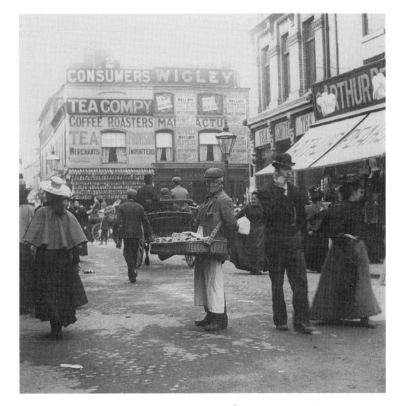

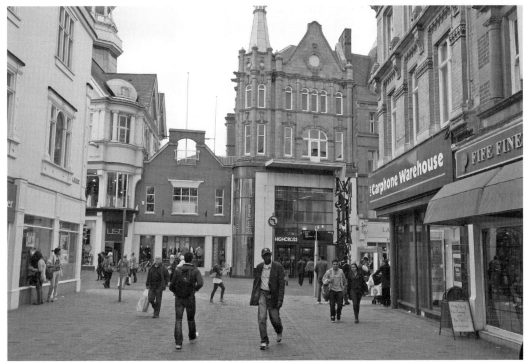

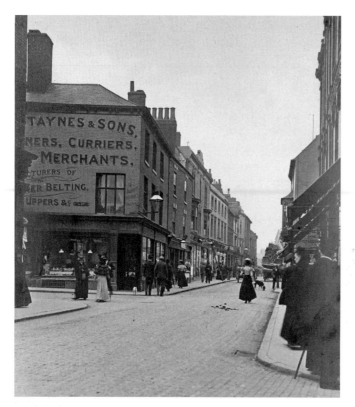

Leicester's High Street has changed almost beyond recognition since our earlier view was taken at the very end of the nineteenth century. The road was widened for trams in 1904 and the impressive red-brick façades followed in the years before the First World War. Carts Lane now boasts a modern turreted building which is just as grandiose. What remains? Well, shoppers still wander up the middle of the road, gazing at a pleasing variety of shop fronts. As for the buildings, only one survives – as the cornices projecting into the photograph from the left foreground show.

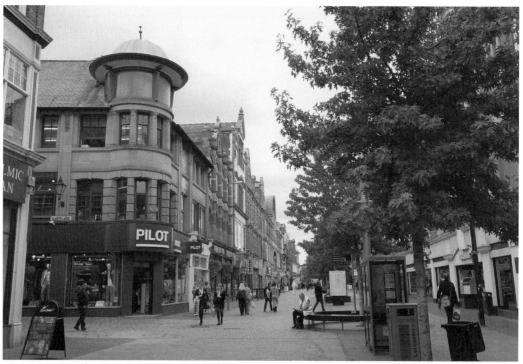

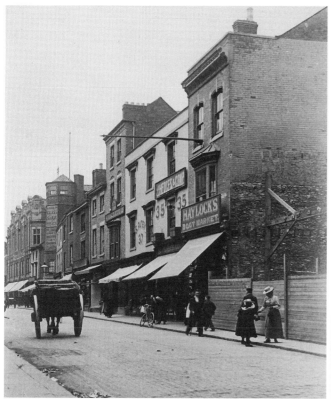

The red-brick façade of the Shires shopping centre now dominates the northern side of the High Street. In the sixteenth century it was filled by the Lord's Place; the townhouse of the Earl of Huntingdon. Until the widening of the street for electric trams in 1904, a single tower of Lord's Place survived, ignored except as an ideal backdrop for advertising hoardings. Now, a pair of plaques record the site of the tower and that Mary, Queen of Scots was once held captive in the house behind it.

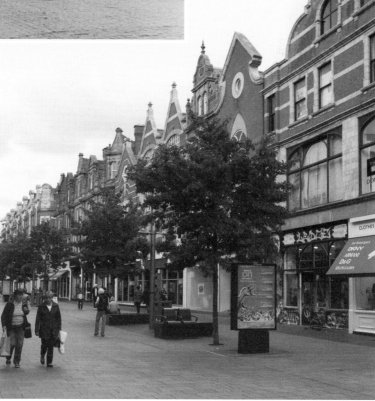

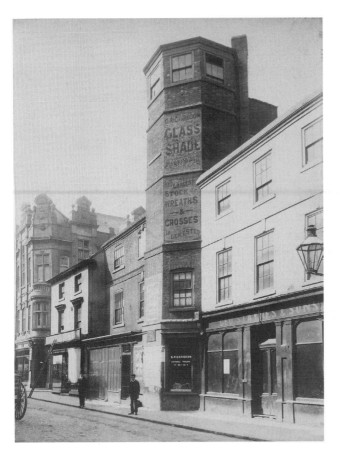

It may be Colonel Sanders rather than Mary Stuart who peers out at passers-by but nevertheless this is the site of the Huntingdon Tower.

A new row of trees precludes a perfect photographic angle but a few paces forward from the Two Seasons clothes shop was that quaint survivor of Tudor Leicester.

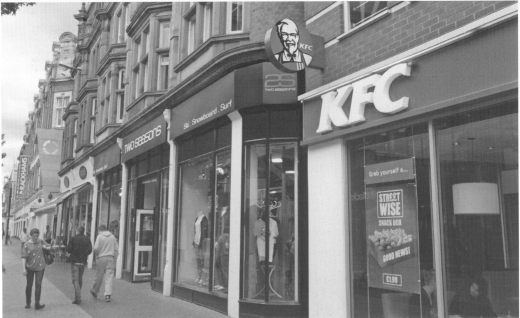

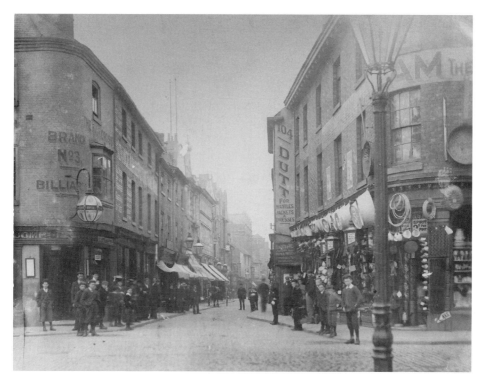

This view of the western end of the High Street, taken a few years before the arrival of the trams in 1904, has been almost completely obliterated. The curve of the pavement is perhaps all that remains. A modern tower block now provides a distant echo of the Huntingdon Tower, the pointed top of which can just be glimpsed immediately to the left of the policeman.

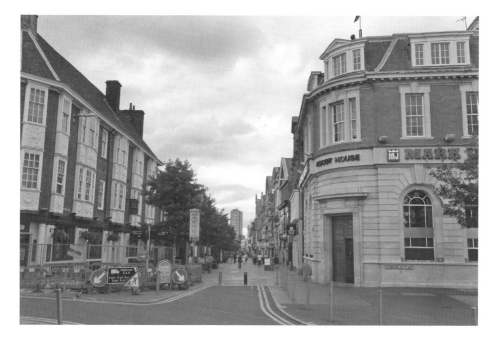

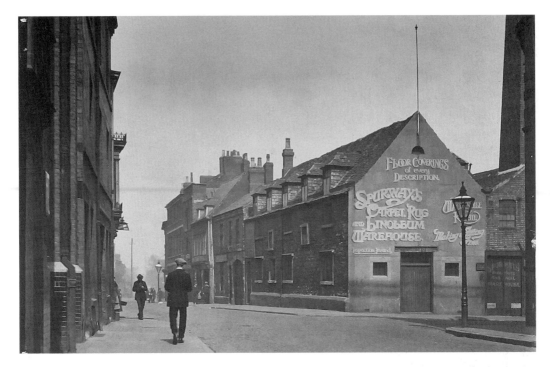

The old Grammar School building of 1573 still occupies the centre of both photographs of Highcross Street, though its original purpose has changed from carpet warehouse to restaurant. No one seems to have noticed, though, that a vast alien spaceship has landed a hundred yards down the road – or is it Leicester's newest cinema (and probably its strangest building)?

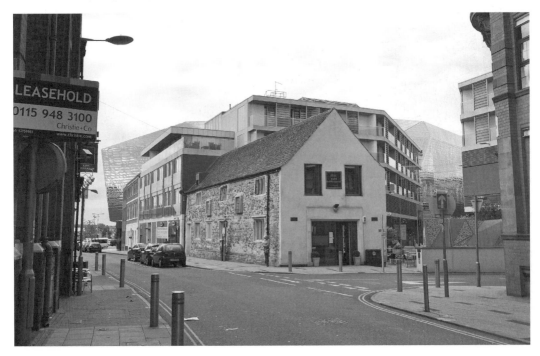

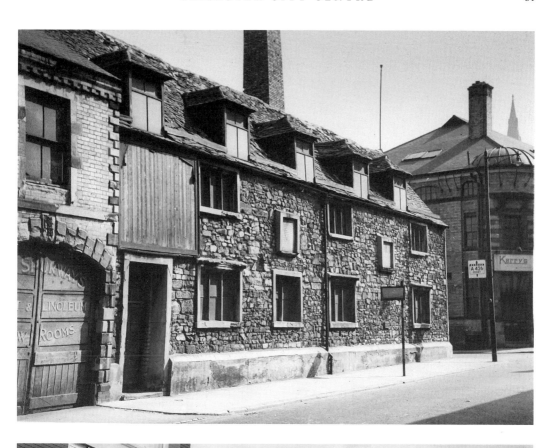

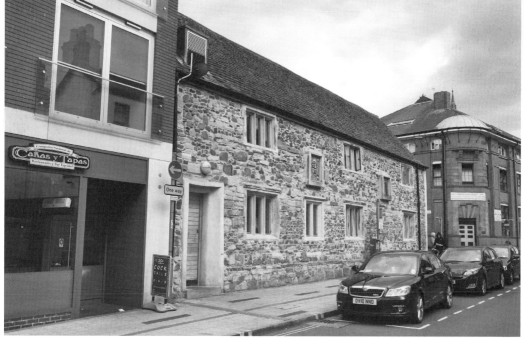

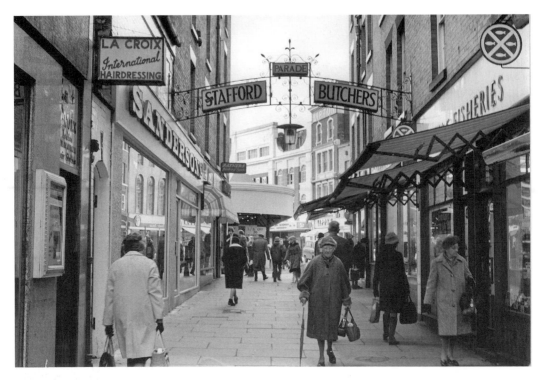

Some areas of Leicester are remarkably unaltered. This entrance to the market certainly has a timeless quality. In half a century hardly a thing has changed. Clothes are different, of course, and the wording on signs has altered with owners and public demand. Otherwise, Victoria Parade is relatively untouched.

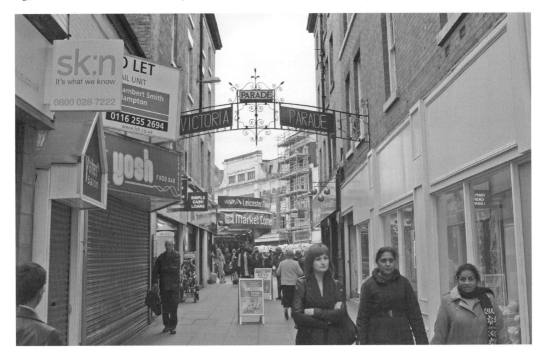

Leicester's market has been thriving since the days of William the Conqueror. At some time between 1103 and 1118, Robert of Meulan (Leicester's manorial lord) confirmed the rights of 'my merchants of Leicester' as they had existed 'in the time of King William'. Jealously guarded ever since, the market remains a key attraction and (as these photographs show) unchanging in spirit and atmosphere.

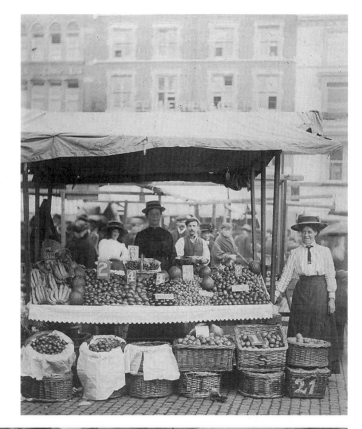

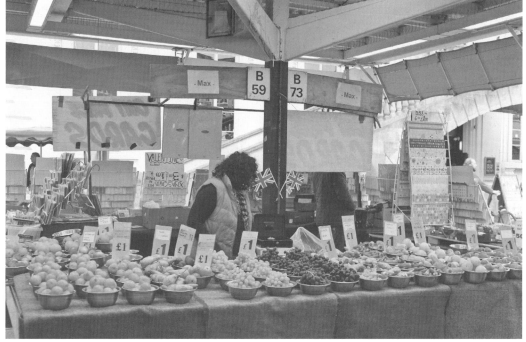

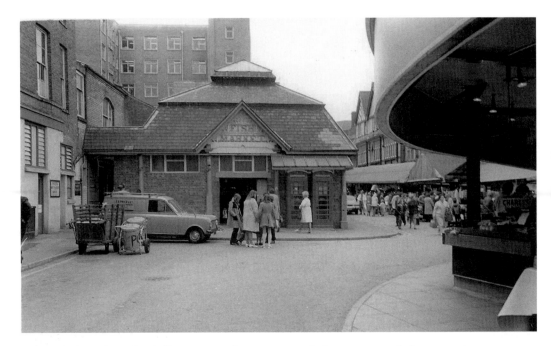

Although the Fish Market hall remains a place to stop and chat – or a good place to park your van – a glimpse beyond shows the developments which have affected this area of Leicester since the 1960s. The Fish Market itself was drastically remodelled in 1978, as part of a redevelopment which saw the removal of the half-timbered market hall in favour of the nondescript red-brick structure which looms at the right rear of our photograph.

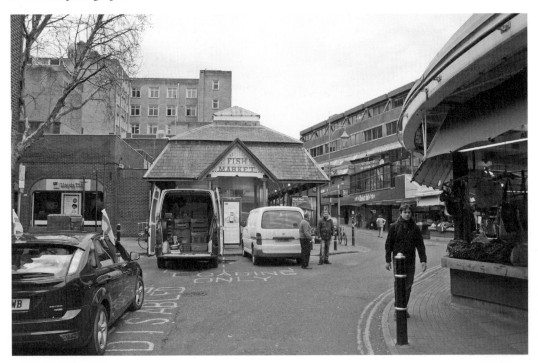

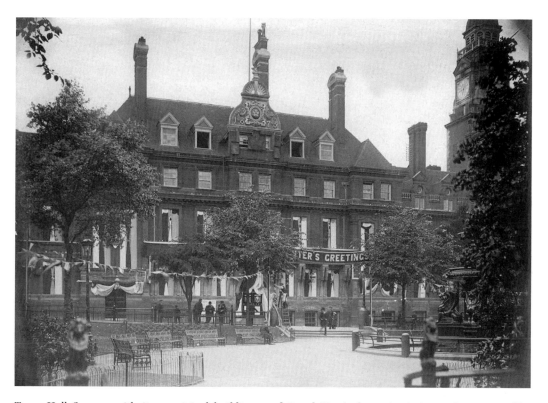

Town Hall Square, with its municipal buildings and Israel Hart's fountain, is instantly recognisable. A century ago the borough was clearly celebrating Easter on a grand scale. Since then the square has been repaved, the seats have been moved around and the pigeons have staged a coup.

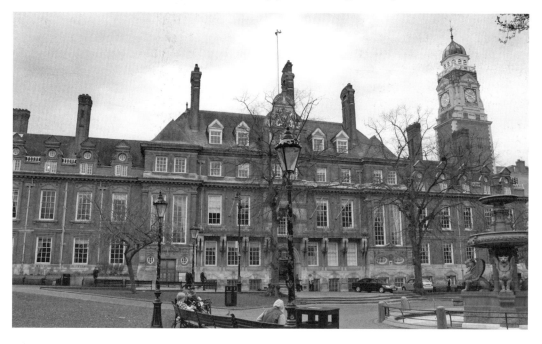

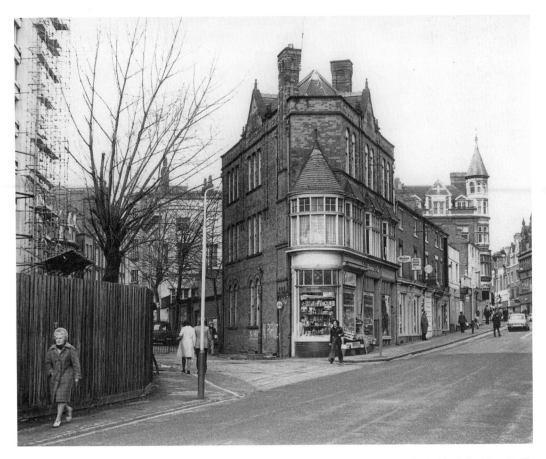

We move now to King Street. Our earlier image here records the building (at the far left) of the New Walk Centre. Completed in 1975, the centre is itself now under threat of demolition. All about it, Leicester's Edwardian buildings carry on, as though their vast concrete neighbour never even existed. The little cut-throughs and eccentric turret-like projections which feature here are a significant ingredient in Leicester's architectural charm.

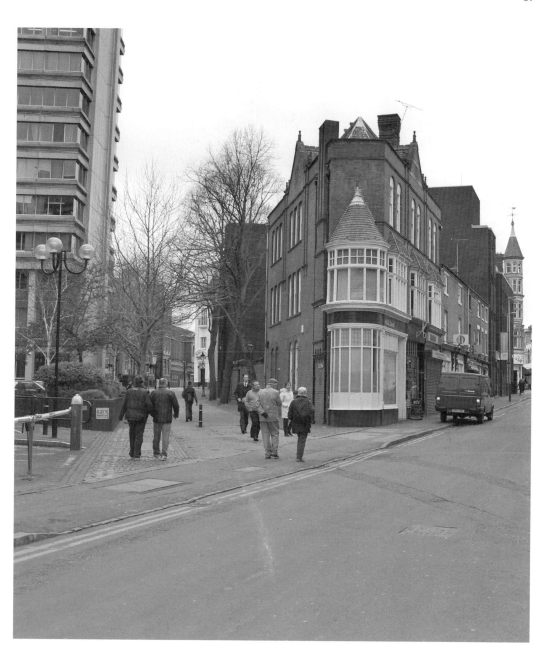

Here we squeeze even closer to the New Walk Centre. The earlier view must be from 1971 or '72 as nothing has yet risen from behind the building site fence at the left. The crude 'no parking' signs provide a link between our two earlier photographs. This is an area which has greatly benefited, as can be seen here, from the City Council's revamping of New Walk, with its tarmac surface and glossy black street furniture.

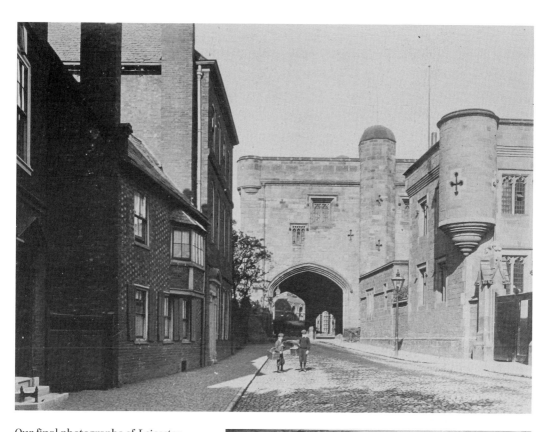

Our final photographs of Leicester (here and overleaf) record the Magazine Gateway into the Newark. The gate is late medieval and for hundreds of years served as the weapons store, or magazine, of the Borough of Leicester and its militia. The Magazine and its associated buildings (built much later but in the same style) to the right, were the home of the Leicestershire Militia and later Territorial Army. Those buildings were demolished in 1966, to make way for the dual carriageway which sweeps past the now-isolated, almost bewildered-looking Magazine. This once-imposing entrance to Leicester has seen many changes in the past half-century; none of them entirely happy. For many years the gateway was left on its own traffic island, serving as the Tigers' regimental museum, reached by means of one of the world's most dismal underpasses.

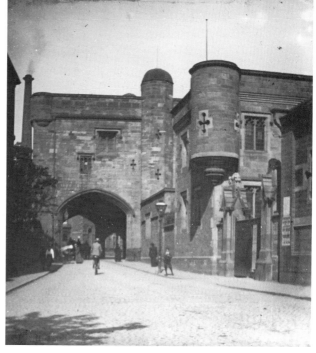

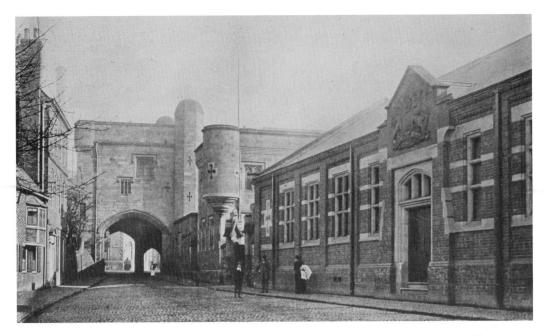

Thankfully, this relic of Leicester's medieval heyday has survived, yet the Magazine Gateway still sits unused, shouldered aside by thundering traffic; seemingly more an embarrassment than the proud icon it should be. It is unlikely that De Montfort University's latest development (in the Lego style) seen to the right in our current photograph, will last as long as its austere neighbour. The crowds from 2012, incidentally, are awaiting the arrival of their Queen, making the first provincial visit of her jubilee year.

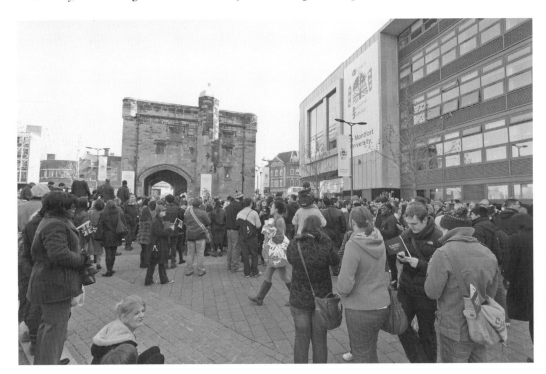

# 4

# LOUGHBOROUGH

Loughborough has probably always been a bustling, busy place. It was bustling when Thomas Burton was making his fortune through wool in the fifteenth century. It was bustling when Luddites smashed Heathcoat's lace machines. With the arrival of the canal and railways nothing, it seems, could stop its progress towards prosperity. Loughborough is the town of Taylor's bells, of Morris cranes and of Brush electrics.

Loughborough is also, of course, a university town. The students are much in evidence and the town's academic side seems more prominent than ever. Even so, we should not forget that the university caters for both sport and technology and it was the technological side that led the way (from its foundation as a Technical Institute in 1909). Loughborough's industrial past, it seems, is never far away.

The town has a lively air and is agreeably different, with individual shops and an absence of too many of the 'chains' which are apt to make our high streets dull and indistinct. The overall impression is of two waves of destruction (or should we say 'redevelopment') in the late 1920s and early '30s and again in the '70s and '80s. In each case it seems traffic was the cause, requiring ever broader roads to keep the motorist on the move.

For the occasional visitor, where Loughborough plays to its strengths, it succeeds. The bell foundry, the Carillon, Charnwood Museum and Great Central Railway all make it a town well worth dropping in on, despite the frustrating one-way system (aren't they all?) and town centre parking problems. Loughborough is different and that counts for a great deal!

This photograph, of the Leicester Road as it sweeps into Loughborough from the south, comes from a postcard franked in 1904. As a first impression, this A6 route into the town suggests that Loughborough has changed surprisingly little and that we might expect a basically Victorian or Edwardian townscape. In fact, it is the late 1920s and '30s rebuilding which has left its mark; though no single era is unrepresented in the town, from the fourteenth century onwards.

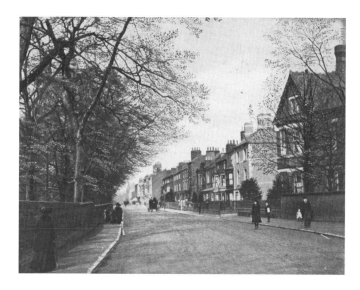

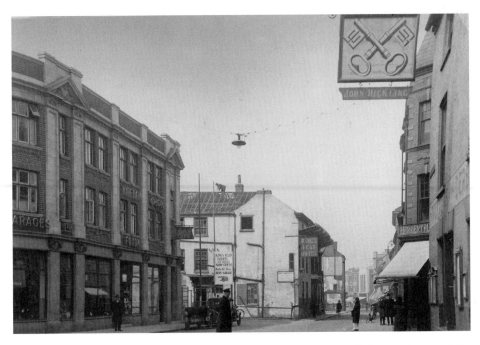

If we approach Loughborough's town centre from the south, our first halt is at the top of the High Street. In April 1929 an alert photographer caught the remodelling of the King's Head Hotel – for street widening. The impressive building next door, now occupied by rather a good toy shop, was new too and has survived unchanged, unlike the buildings beyond Pinfold Gate to the right.

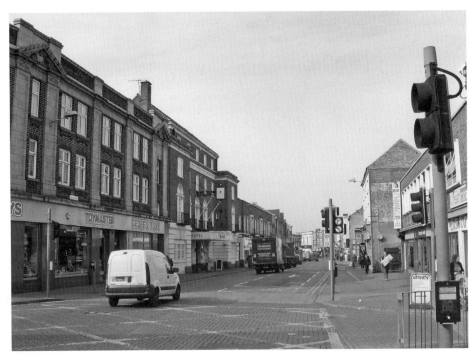

A little further down the High Street, the old Leicester Permanent Building Society offices are also still clearly recognisable. When the earlier photograph was taken, in 1929, they were new – part of the great remodelling that engulfed Loughborough in the 1920s and '30s. Little has changed since, proving the sense of sensible design and good building material.

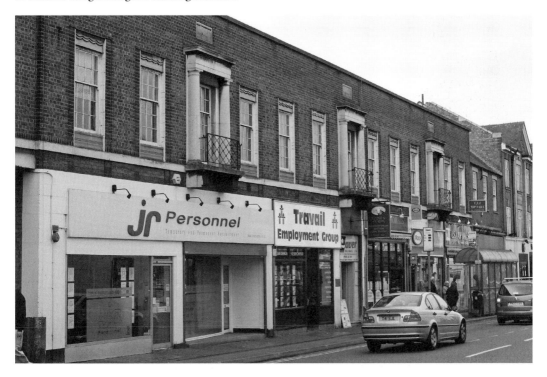

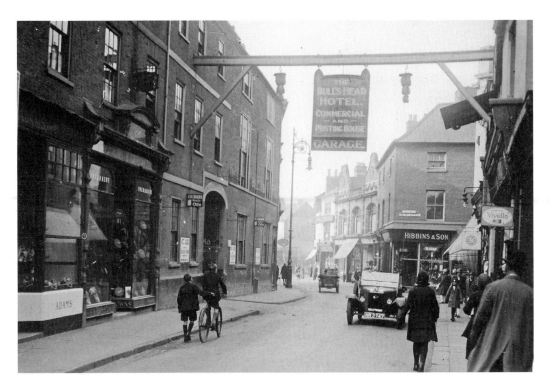

We now reach an almost unrecognisable scene as the High Street reaches the Market Place and Baxter Gate. The main road through Loughborough had been straightened for mail coaches and the turnpike; in 1929 it was widened for the Bullnose Morris and Austin Seven. Our first photograph shows the narrow street of 1927, lined with Victorian shops and offices. Not one appears to have survived!

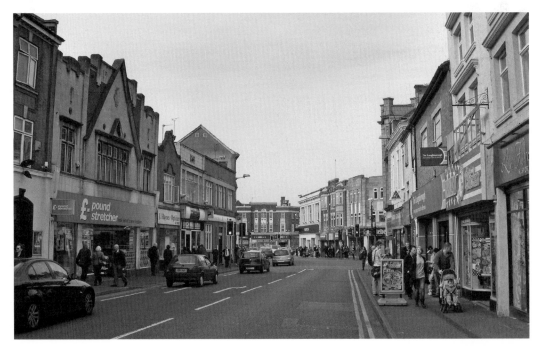

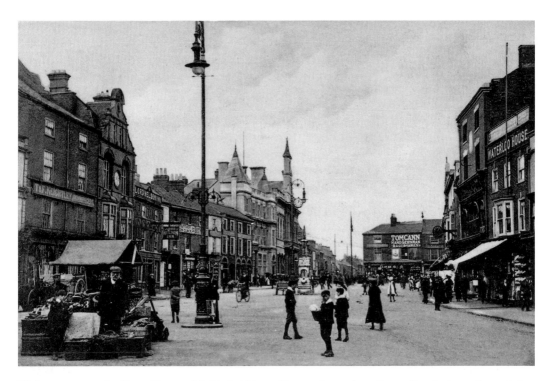

We have now reached Loughborough's Market Place. Changes here, since the earlier photograph was taken in 1908, have been piecemeal and have therefore largely preserved the original building line. The bellcote and clock of the old Corn Exchange on the left are unchanged – as is the bustling atmosphere.

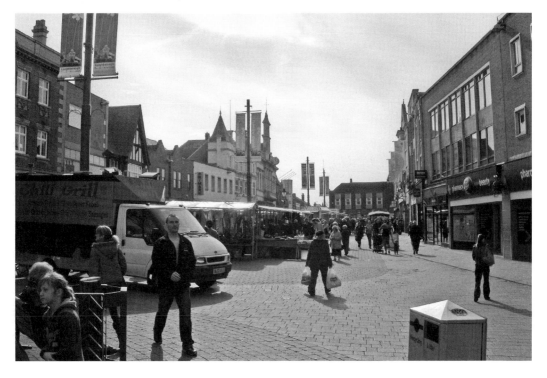

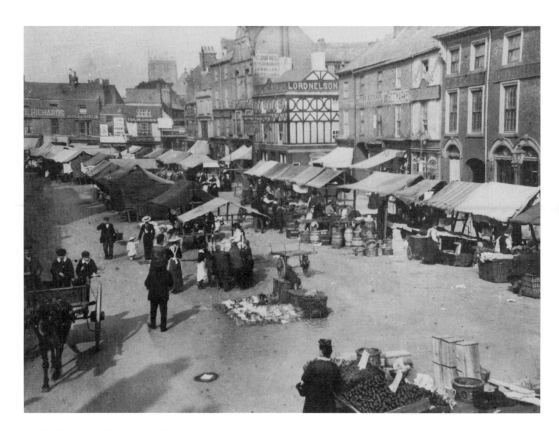

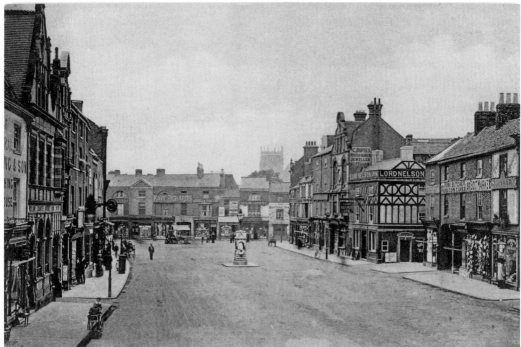

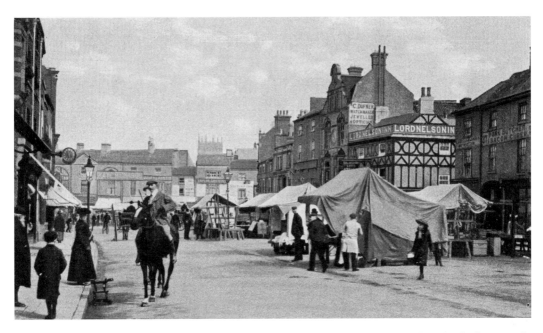

We now have three more views of Loughborough's pleasantly busy Market Place, this time looking north. All were taken in the decade preceding the First World War. Many of the buildings skirting the market have since gone, though there is an appearance of continuity, as their replacements occupy the same frontages. Plastic and polythene have replaced tarpaulin and wood in much the same way. Luckily the parish church still pops up to give us a fixed point for our comparison.

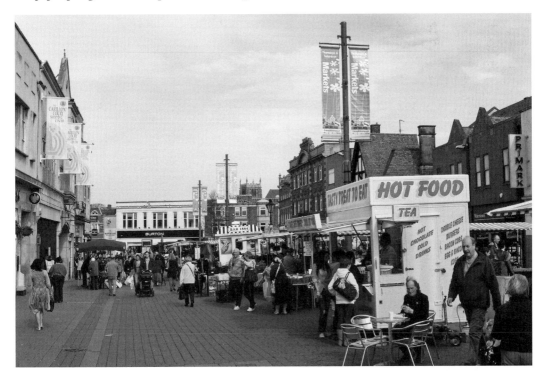

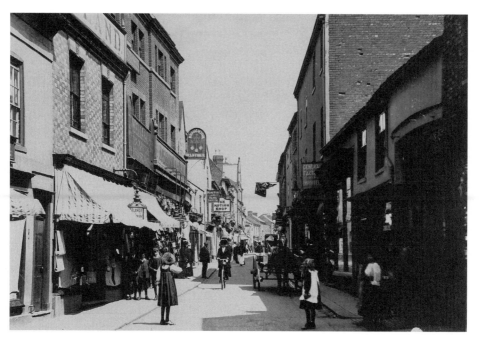

We must turn up Biggin Street now, to stand with our backs to the Unicorn, for a largely unchanged view up Church Gate. In 1900 this junction with Biggin Street was more constricted but in the last few years the last few shops of Church Gate have given way to an open space where taxis turn and diners sit on the pavement as though it were Luxembourg, not Loughborough . Little else has changed. This agreeable, narrow shopping street is still happily cluttered with awnings and signs, prams, bicycles and pedestrians.

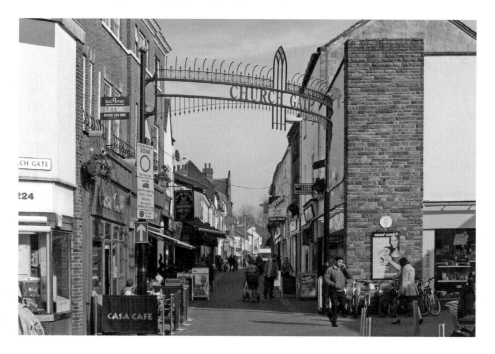

We proceed now to the top of Church Gate. These days, Steeple Row offers a peaceful area of garden and a useful stretch of two-hour car-parking, but in 1913 it was a narrow entry between shops. The writing was on the wall for the buildings, however (in the case of Sanders and Hayes the signwriters all too literally), as they were marked for demolition. Luckily, All Saints' tower survives unaltered.

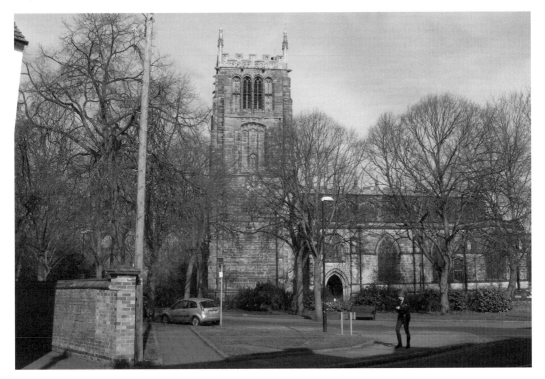

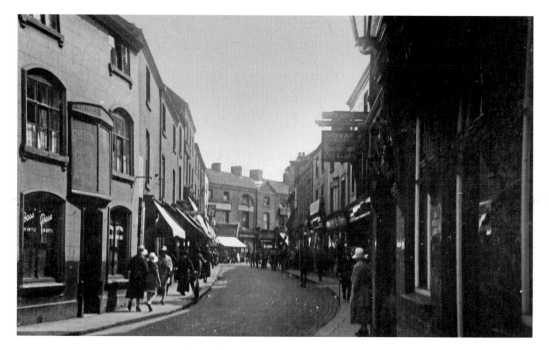

We must return to the Market Place once more and this time turn up Swan Street. Just before Derby Square we face about to compare views from 1926 and 2012. Little remains, save for a couple of shops in the block to the right, showing how much the centre of Loughborough owes to the redevelopment of the 1930s.

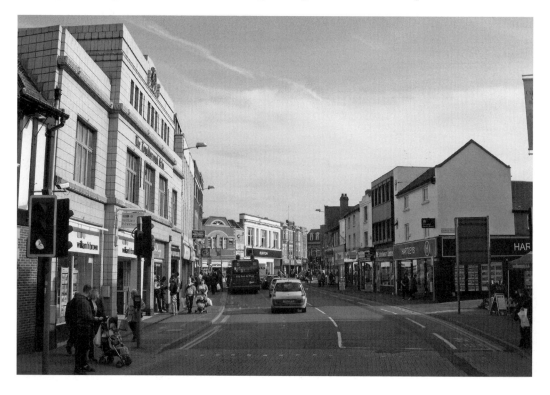

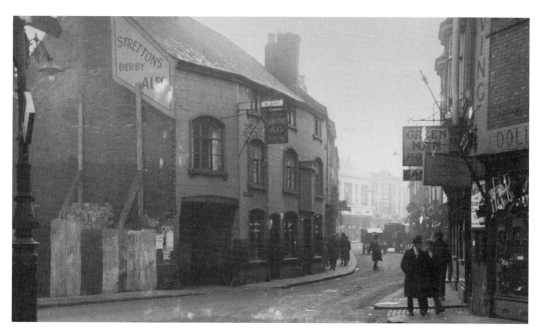

A little further down Swan Street we can see the redevelopment work in progress. In this view from 1931 the new Saracen's Head public house is rising beside the old. The site was soon to be taken for the *Loughborough Echo* offices. Swan Street has also been widened, so that while in 1931 the white façade of Burton's was the first building visible on the Market Place, our modern view shows a nondescript red-brick shop to the left. Sadly, the interesting-looking toy shop to the right is long-gone, as is any real hope of character or old-world charm.

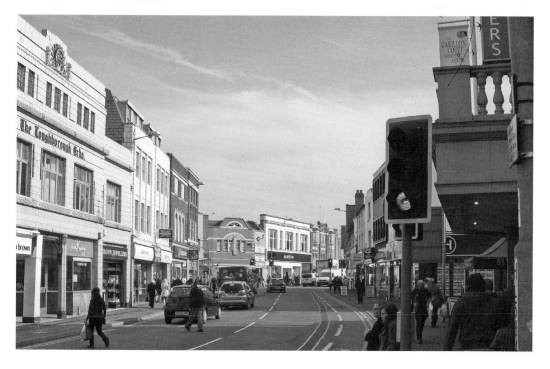

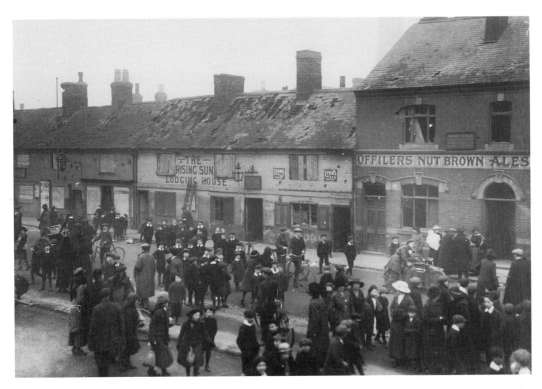

Finally, we reach The Rushes. The name is now probably most associated with a shopping centre but on the last day of January 1916, it was made infamous as the target of a German Zeppelin. The bombs dropped from the airship killed six women and four men in Loughborough, one woman in The Rushes, where (as the photograph shows) considerable damage was also done. It is almost too facile to add that what Kaiser Bill began, Loughborough's town planners have completed. Try crossing from one side of the road to the other!

# 5

# LUTTERWORTH

Lutterworth was once described (in a guide to Leicestershire of 1912) as 'a pretty little country town embowered in trees on rising ground above the river Swift.' Well, the twentieth century has altered that somewhat! Lutterworth is all too often a town to be driven through, or driven around. The motorway and dual carriageway which skirt the town to the west, linking it with the Magna Park, have rudely shoved the trees and River Swift aside. The Gloster Meteor which swoops across one roundabout is an imaginative and impressive reminder of Frank Whittle's presence in the town but, to our taste, it still can't compete with the willows and running water.

Lutterworth retains much of its grandeur as an old coaching town. The Rugby to Leicester Road is still impressive, with what must have been quite a haul up the hill into the town for horse-drawn coaches. Now, it is all cars and lorries – which aren't so picturesque.

The parish church also retains an aura of historical significance, helped by the peaceful approach up Church Street, with its half-timbering and thatch. This was Wyclif's church of course and visitors will find many reminders of the reformer in the church and about the town. The depiction of the Last Judgement above the chancel arch must have kept many a Lutterworthian on the straight and narrow since it was painted in the fifteenth century. For those who erred, Lutterworth still boasts one of the oldest (if not the oldest) police stations still in use.

The town museum is well worth supporting, and the shops around Market Street and Church Street are agreeably independent and individual.

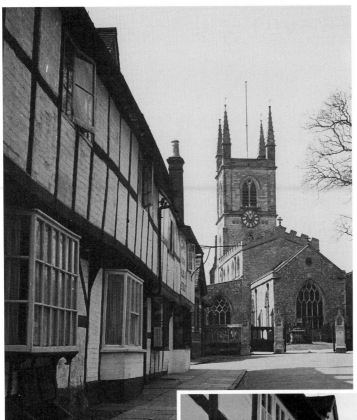

The timeless quality which half-timbered or thatched buildings give to any street, seems to be true enough in the case of Church Gate, which hasn't changed in the fifty or so years since our earlier photograph was taken. The bracket, which once held the sign of the Coach and Horses, has gone, but otherwise little has altered.

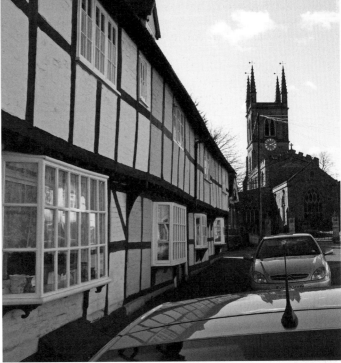

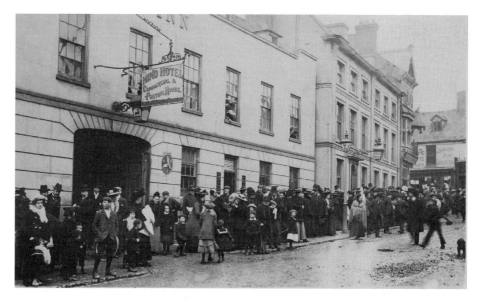

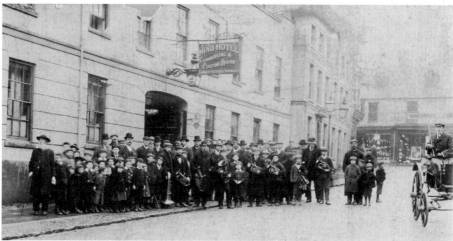

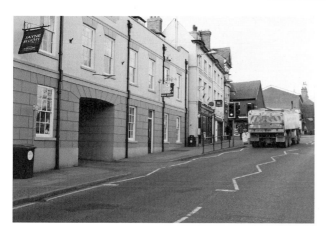

Our two old views of the Hind Hotel further up the High Street both date from 1905. Although the Hind has become Hind Estates, the building is largely unaltered. Behind the grinding lorry, sadly a feature of modern Lutterworth, the corner of Church Street shows that other development has taken place. We do not know what events were taking place in 1905; though it may be the local hunt. The town band, which still meets for its practices at the town hall, has turned out, though it seems sadly depleted without cornets and trombones.

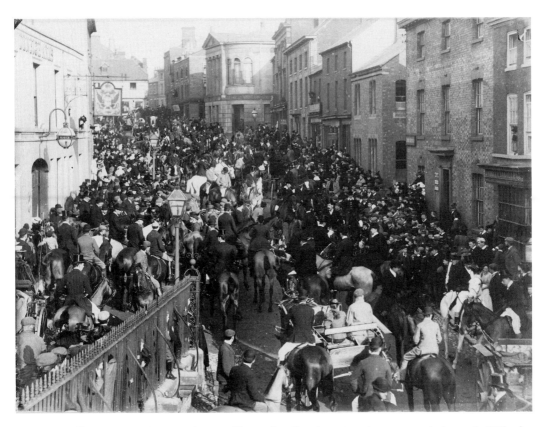

For once traffic congestion is greater in our older, rather than in our contemporary, photograph. Little else has changed in Lutterworth's High Street, since the meet of the Atherstone Hunt was photographed at the turn of the twentieth century. We cannot replicate the Victorian view from an upper window but otherwise it is harder to spot the changes than what remains.

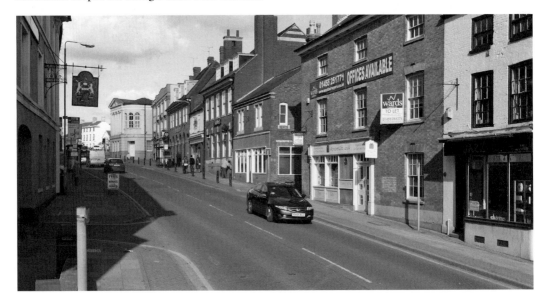

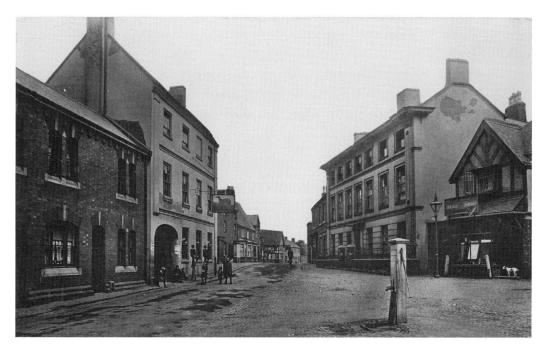

The pump and lounging bicyclists have gone in the hundred or more years between these photographs of Market Street. We have laboured up the hill and now gaze at an otherwise largely unaltered scene. The Greyhound has benefited from a lick of paint, as has the block of offices opposite. The true skill of our photographer is evident here in capturing a modern view without an unbroken stream of traffic!

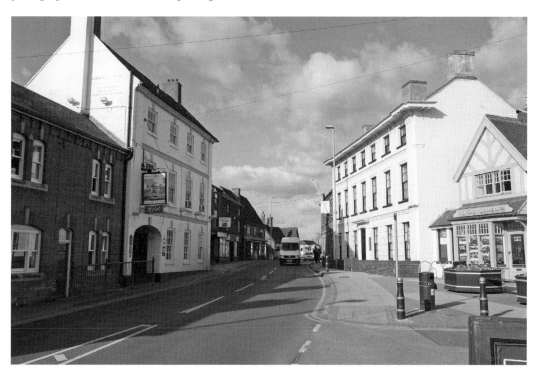

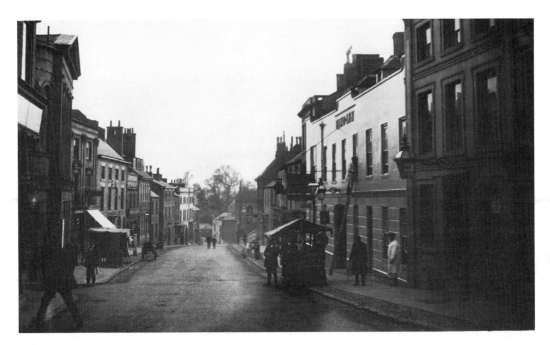

Here we pause and gaze back down the High Street. A new building (with prominent dormer windows) has squeezed in half-way down on the left but otherwise, little has changed in the past ninety or one hundred years! The town hall, designed by Joseph Hansom (of Hansom cab fame), provides a point of reference on the left, where the stuccoed portico rises above the surrounding buildings in both photographs.

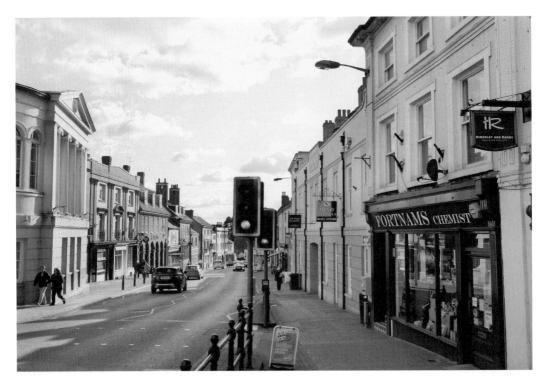

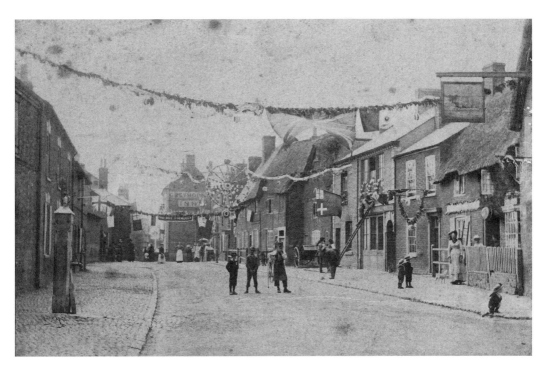

Here, the Greyhound Inn acts as a breakwater around which the torrent of change has rushed. In another year it may be that the public house on the right, the Greyhound's only ally against progress, may also have succumbed – it is already boarded up. The earlier photograph records Lutterworth's celebrations (probably) for Queen Victoria's Golden Jubilee in 1887. Quite apart from the bunting and loyal banners, it is a fascinating record of an old coaching town, with thatched roofs and a main street studded with inns.

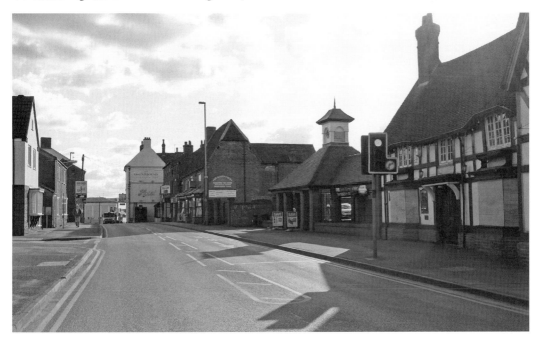

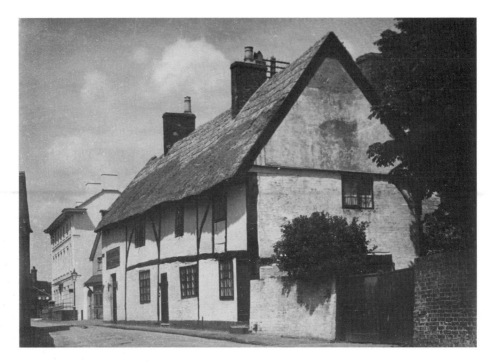

Thatched roofs survive in Bell Street, a little spur off the Market Place. The earlier photograph was taken half a century ago by F.L. Attenborough, the father of David and Richard, who was appointed principal of the new Leicester University College in the 1930s. His interest was certainly in the sixteenth-century cottage, which (despite the encroachment of the car park) seems to be thriving as the Shambles.

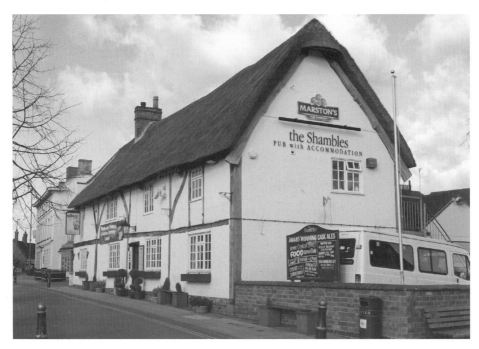

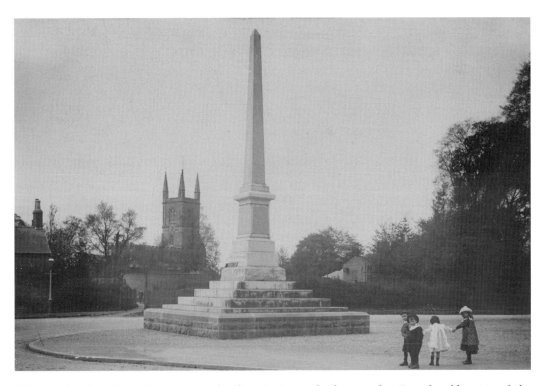

We must double-back up George Street for these Lutterworth photographs. Here the older view of the monument to John Wyclif comes from a postcard posted in the town in 1912. Woe-betide any little tots who wished to play beside the busy junction now, as the heavy traffic (once again miraculously absent due to the patience of our photographer) makes crossing the road here a hazardous operation indeed.

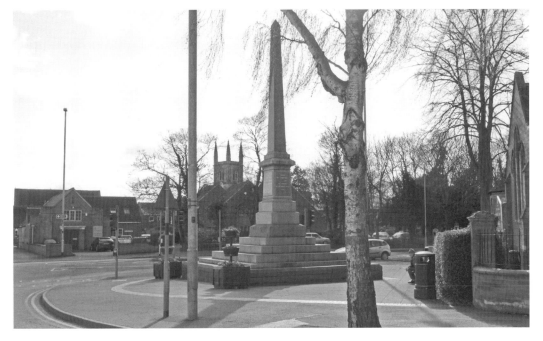

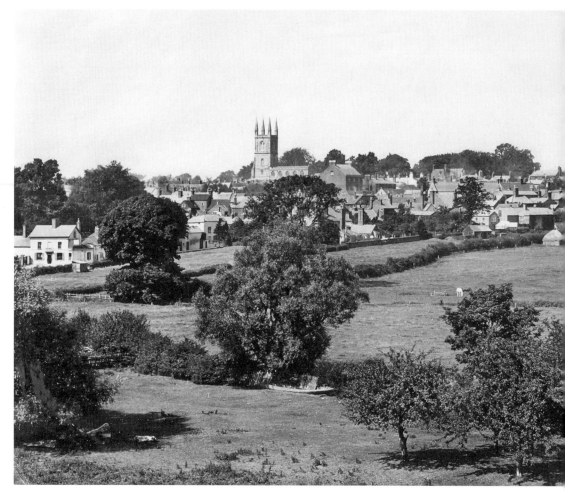

Lutterworth, the sleepy market town, dozes in the summer heat a century ago. Junction 20 of the M1 now occupies this side of the town. It is not, we feel, entirely an improvement on hay-ricks and grazing animals.

# 6

# MARKET HARBOROUGH

To most people Market Harborough is known not from personal acquaintance but rather because of a story told of the absent-minded G.K. Chesterton, who telegraphed desperately to his wife; 'Am in Market Harborough, where should I be?' It is a pity because Market Harborough is a pleasant town, with plenty to justify a visit.

It is not really an ancient settlement, having been created from the parish of Great Bowden to take advantage of trade caused by a new crossing over the River Welland in the late twelfth century. The town layout is certainly centred upon the market place, which was once huge before permanent buildings began to encroach where there had previously been only stalls and animal pens.

Like all towns it struggles to cope with road traffic, which has either to be diverted, kept moving or found somewhere to park. It is only a few years since the A6 was diverted away to the east; how that traffic would have fared with the conflicting tangle of pedestrian crossings and traffic lights that characterises the modern Square, St Mary's Road and High Street cannot be imagined.

This was the home of Symington's soups and Symington's corsets – the latter branch of the family being the inventors of the Liberty bodice of blessed (or detested) memory. You'll struggle to find much evidence of the Symingtons in town now, though the council's offices occupies their old factory and includes an excellent museum which is well worth an hour of anyone's time.

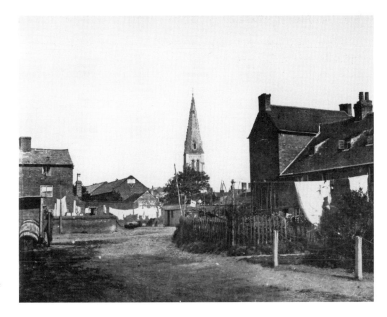

This photograph of Market Harborough, from perhaps as early as the 1850s, is a timeless view of a town caught unawares. The parish church presides over all but we are amid the washing, the carts and the bean-poles of the town's folk – not their well-swept squares and decorated shop fronts. The photographer labelled it himself as 'the back entrance to town'.

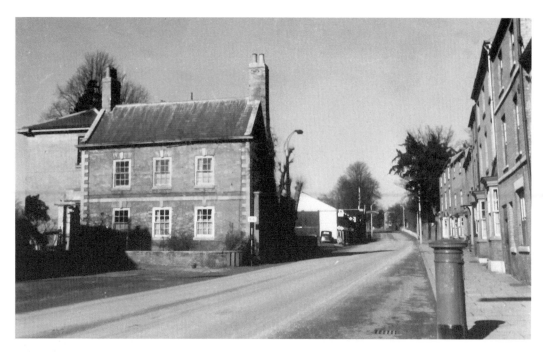

At first sight, this northern approach into Market Harborough seems to have changed very little in the fifty years since our first photograph was taken. Apart from the growth of a few trees, the alterations all seem to have accommodated the motorist. The entrance to Bowden Lane (on the right) has been widened – altering the building line and moving a pillar box – and the proliferation of street signs is startling.

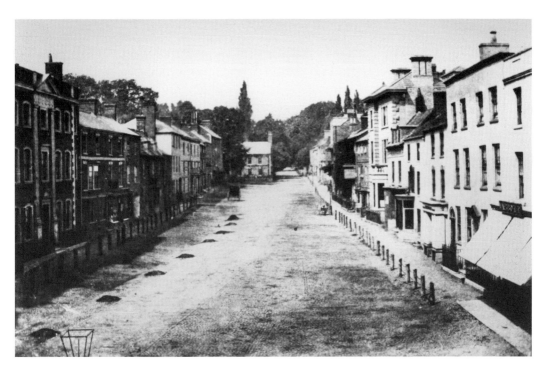

Alas we cannot quite recapture the angle of the earlier view of Market Harborough's High Street, taken as it was from an upper window of the old town hall in about 1860. Don't allow the traffic to obscure how few changes there have been here too – especially above the level of the shop fronts.

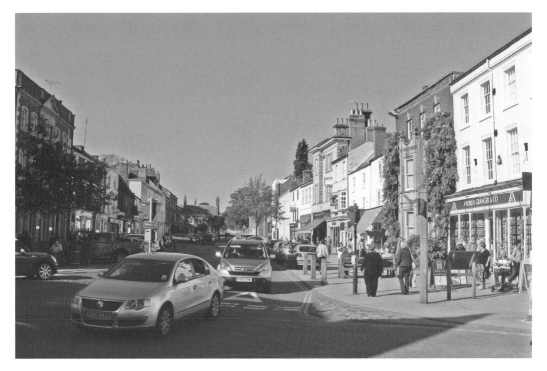

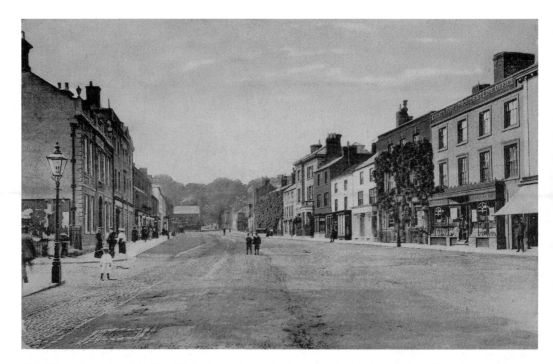

This Edwardian postcard of the High Street demonstrates perfectly the devastating effect of the motor car. In 1900 children played in empty streets. Now, we pay a terrible price for our mobility as we are choked by fumes and herded onto street crossings. Even our attempts at photography are ruined by cycle route signs, slapped between bollards in the centre of the road!

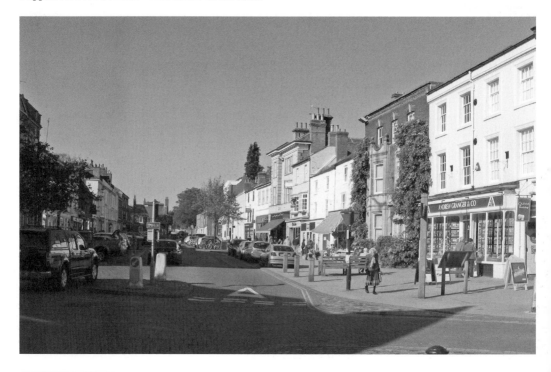

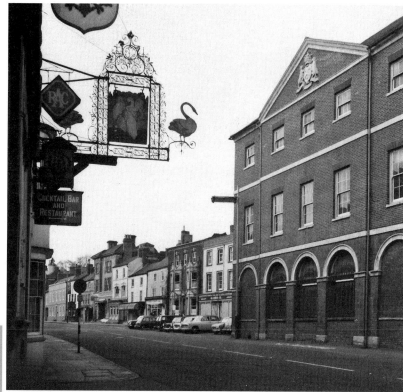

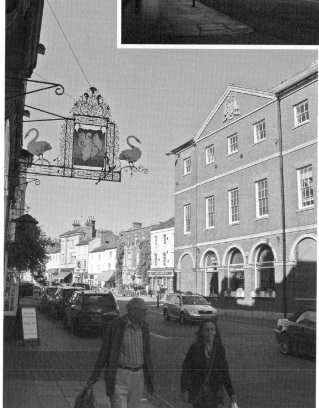

Once again it is about half a century that separates our two views of the High Street. The sign of the Three Swans (an inn made famous by the cantankerous and eccentric John Fothergill) survives where all others have gone west, while the town hall opposite, built by the Earl of Harborough as a shambles in the 1780s, still bears his arms.

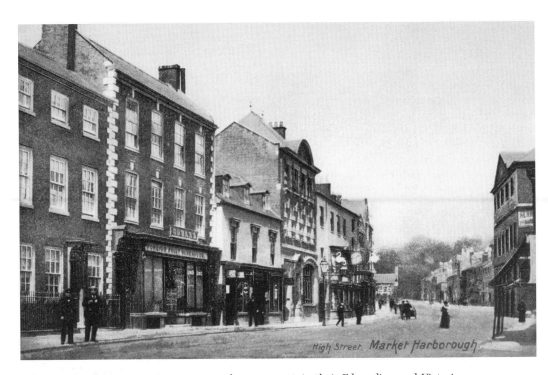

We are lucky that, in most cases, our market towns retain their Edwardian and Victorian appearance –
above the level of the shop windows. Market Harborough is no different. Strip away the plastic signs and
shop windows and gaze at the upper floors. Only the 1930s front above Savers and the new windows and
paint over Peacocks indicate the assault of progress.

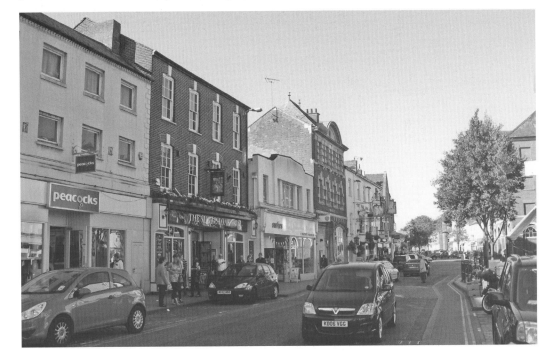

A curious view of St Dionysius's Church from the 1940s, which manages against all the odds to omit the old, timber-framed Grammar School building. Little has changed. John Briton's shoe shop has given way to Lloyds, while the hardware store of Mawer and Saunders (already nearly fifty years old when the first picture was taken, lasted until the 1990s as a major shopping landmark.

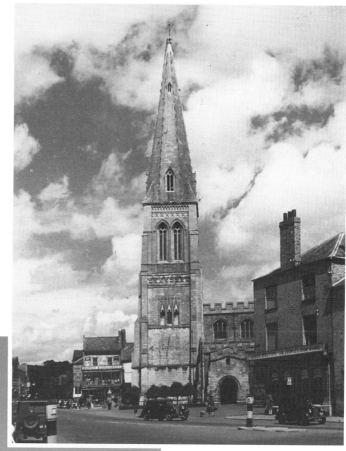

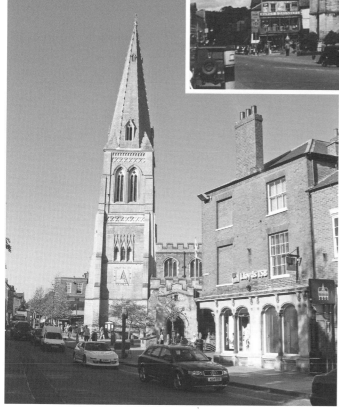

Oddly, the later photograph makes more sense. Now, this view shows a pleasant community space, with benches and an information panel. The earlier photograph, taken perhaps in about 1970, seems to capture neither the Grammar School nor church particularly well and shows only an empty yard. Interestingly, the buildings of the High Street here have been renovated – Edwardian chimneys and dormers giving way to the flat roofs apparently so beloved by modern architects.

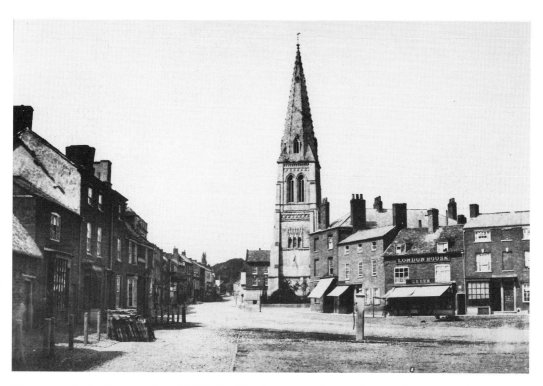

We are now in the Sheepmarket of 1855. It is The Square now but until 1903, the old name was well and truly earned – as the stacked hurdles to the left of the earlier photograph attest. The buildings to the left are new but beside the church astonishingly little has changed. The pump has gone and someone has planted a couple of trees, but there is no doubt that the area is familiar enough to be recognisable.

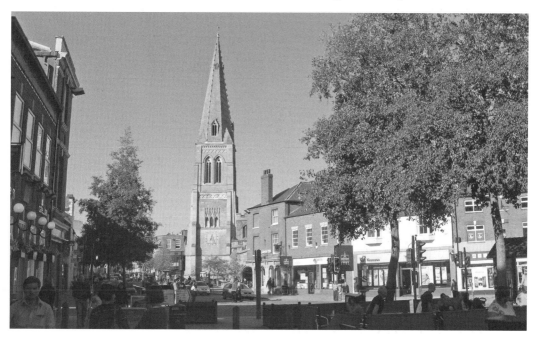

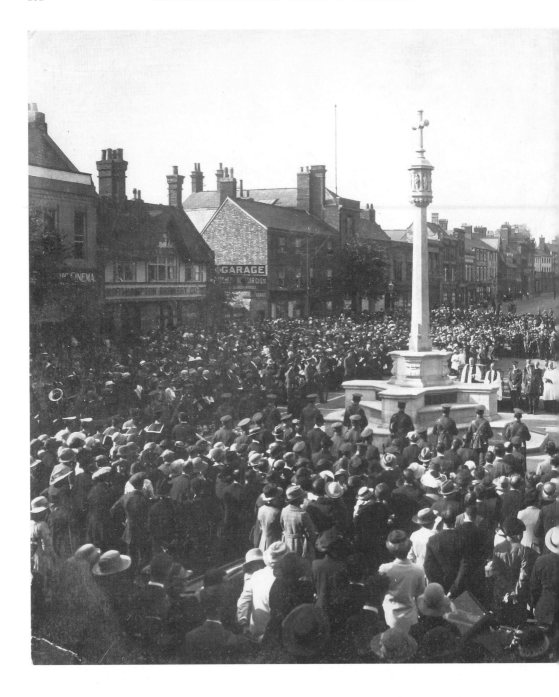

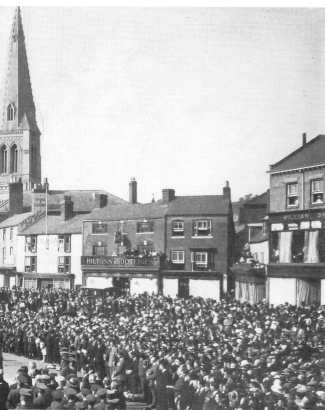

Two views of The Square; the first an emotional shot of the first Armistice Day service in 1919 and the second from early autumn 2011. Without the first photographer's vantage point at an upper window, we cannot exactly duplicate the view. Nevertheless, it is clear how different the western side of The Square is today and how similar is the other.

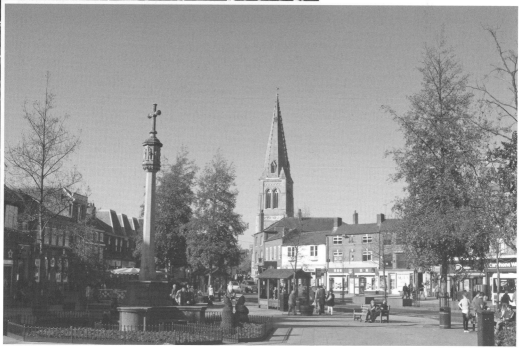

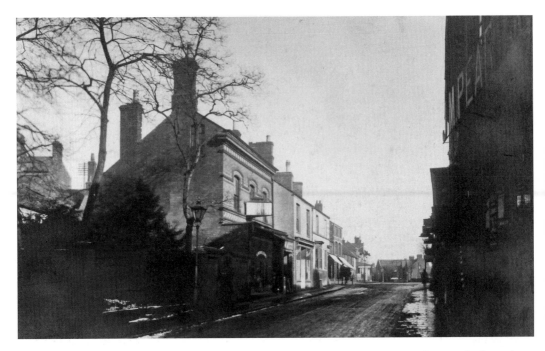

We have strolled across the Northampton Road to gaze now down St Mary's Road, towards the railway station. It is hard to see any common features in these photographs: one from about 1900 and the other from 2011. The most remarkable survivor is the three-storey brick building in the centre. In 1900 it was at the end of a terrace of five or more and despite the slush in the gutter, had its sunshade out.

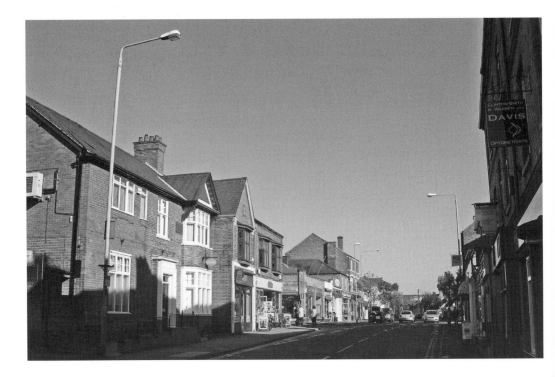

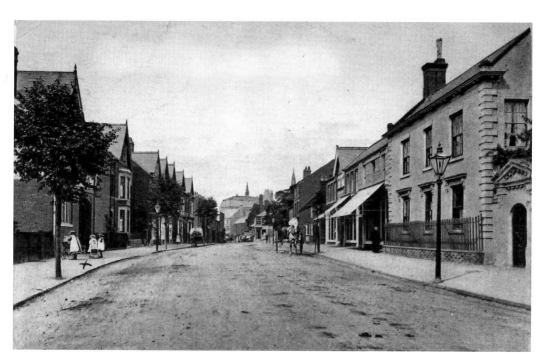

We have now marched further down St Mary's Road, turning finally to face the town centre. Where, in 1900, there was once horse manure, there are now painted white lines. The church spire again comes to our aid and we see that, though there are gaps and modern intrusions, the street is surprisingly unchanged.

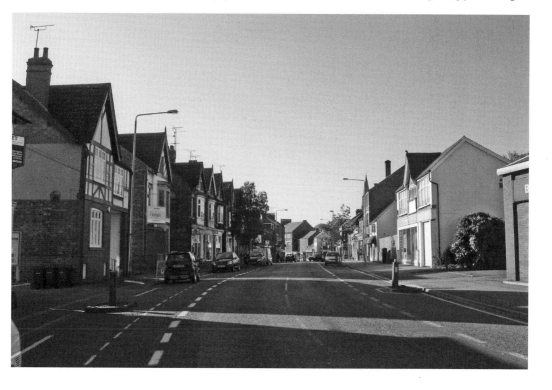

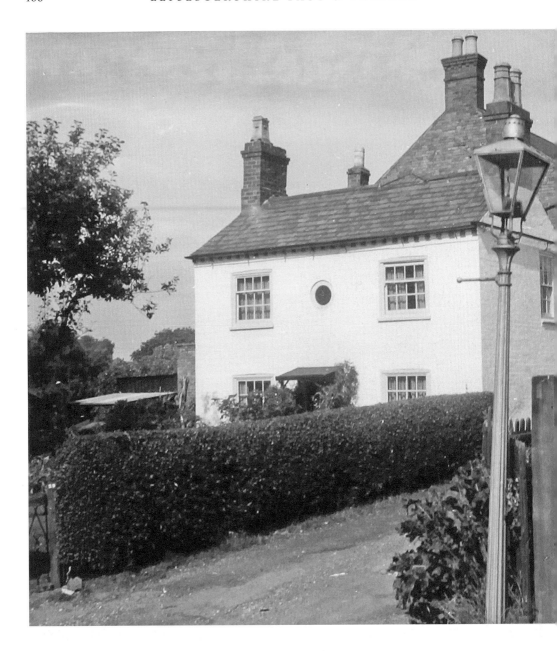

It is hard to camouflage Mill House, up Mill Hill on the eastern side of Market Harborough. Even if you were to demolish the building behind, extend the house to the left and allow the hedge to grow another couple of feet; we'd still know that curious circular window anywhere. These photographs date from 1960 and 2011.

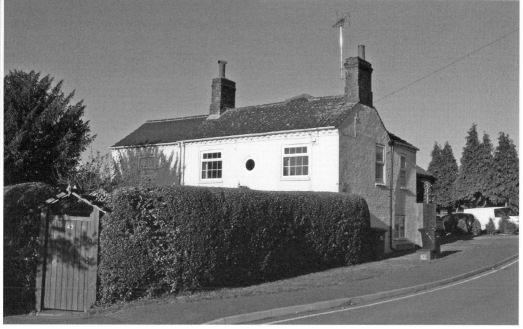

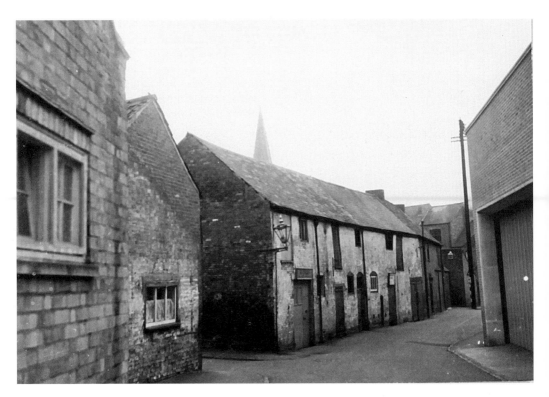

We nearly gave up on this one. We are looking westwards down King's Row in about 1960. The church spire acts as our anchor here but even so, with new buildings of a different height, it takes a while to orientate oneself. Even what appears to be a new shed or store on the right has vanished. The clue lies in one gable (in the centre) and on the far roof line. Can you work it out?

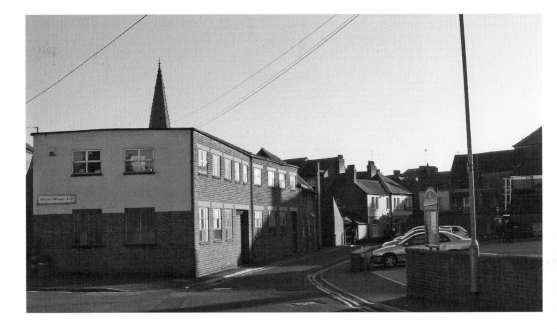

# 7

# MELTON MOWBRAY

Melton is well worth a visit. At first sight the traffic seems heavy and it can be hard to find a parking place – but how many towns can truly be said to have solved those problems? Besides, once free of your car, you strike out for the town centre and find it entirely pedestrianised. It is a pleasant surprise to find yourself able to walk freely and safely, amid some interesting and unusual shops.

The best view of Melton is probably that from the south, especially when the sun lights up the tower and clerestory of the parish church. It is a church which is generally open to visitors too (which is good) and to be recommended. Those on duty within are friendly and have much to show their visitors.

The town is unusual in having three local delicacies with which to refresh the jaded traveller. Stilton cheese is a regional product it is true, but there can be no denying the 'made in Melton' label on hunt cake and pork pies. The pork pie has made Melton Mowbray famous the world over – even in European courts of law, where the same sort of status has been sought for the Melton Mowbray pork pie as is enjoyed by Champagne, Parma Ham and (we imagine) the Cornish Pasty.

According to some, the pie was designed as the ideal fox-hunting snack (presumably as you can't eat fox); being both sustaining and easily portable. Once the 'hunting Metropolis', Melton still boasts a number of 'hunting boxes'; those well-set-up residences occupied by wealthy visitors for the season. The hunt brought trade to the town, which is perhaps why escapades such as 'painting the town red' (in which a set of young bucks and scamps did just that) were tolerated if not actually revelled-in.

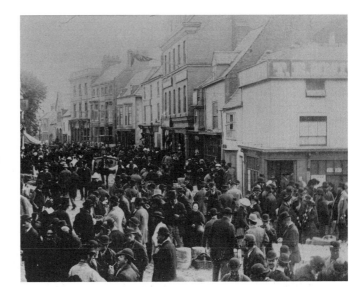

This delightful photograph of Melton's cheese fair, some time in the 1890s perhaps, will serve for both traditional and new Melton Mowbray. Stand on the Corn Cross one Saturday and look down towards the Market Place. You'll see what we mean: a bustling, jostling, good-natured sea of people about their business. They may not wear bowlers and bustles any more (more's the pity) but they're the same people all right.

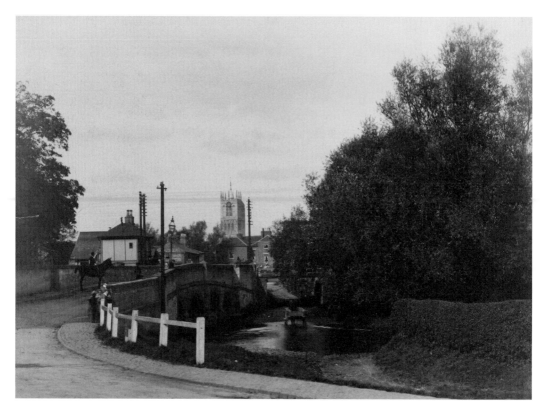

Few photographs demonstrate as clearly as this the changes wrought by the twentieth century on Melton Mowbray. No horseman would pause for a chat on the Burton Road bridge today and to reach the ford would require superhuman determination and the felling of a dozen or more fast-growing evergreen trees.

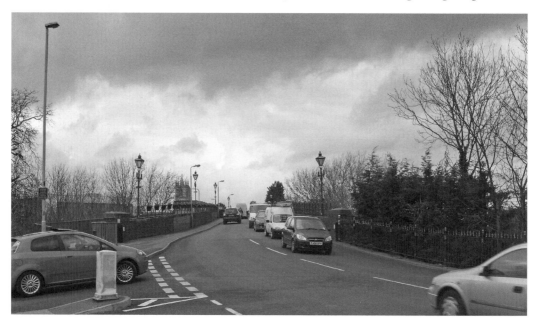

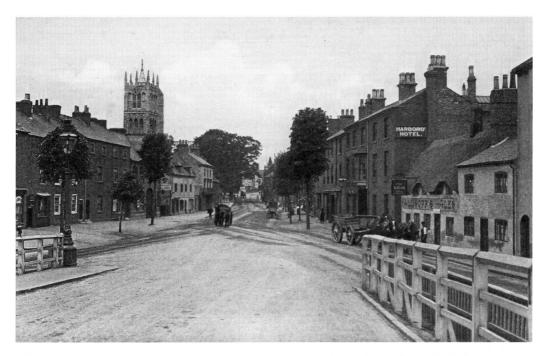

Although it now hides beneath a coat or two of white paint, the Harborough Hotel still dominates the right-hand side of Burton Street as it runs into the heart of the town. Surprisingly little has changed here since the Earl of Cardigan kept a hunting box in Burton End, and were he to stroll up to the church, only Autostop, which replaced the thatched inn beside the hotel, would seem unfamiliar.

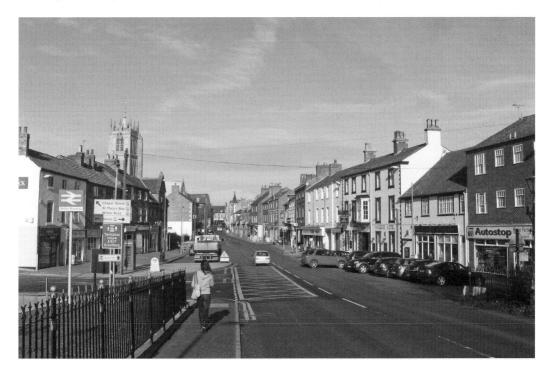

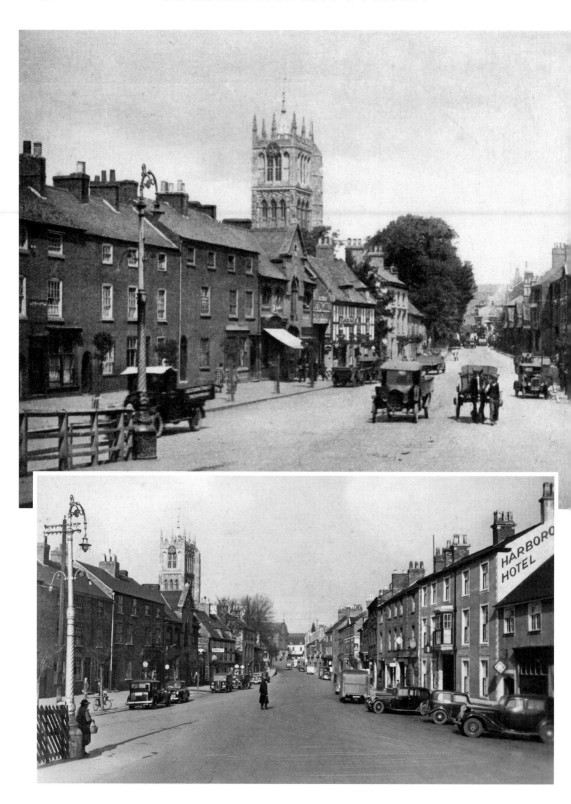

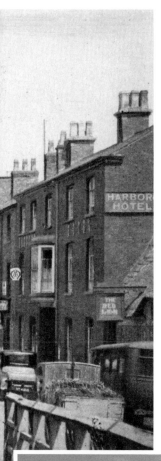

*Left:* A few paces towards the town and an advance of half a century in time. Motor cars have made their appearance, though the cars and vans still share the street with horse-drawn traffic. The Harborough Hotel proudly sports its AA badge and a garage (timbered style) has opened to serve the motorist. Intriguingly it is the garage, rather than the early Victorian hotel, which lost the struggle to survive – and left the 'hole' beyond the lorry on the left.

*Opposite, bottom:* A generation on and little has changed in Burton Street. The traffic is heavier but still nowhere near the spirit-crushing, ear-battering level of today. Parking seems to be no problem for the motorists of the 1940s and only the most daredevil pedestrian would stroll across the road so carelessly now.

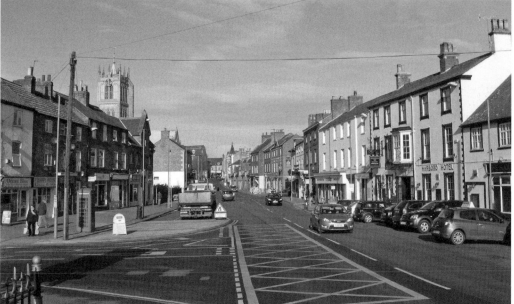

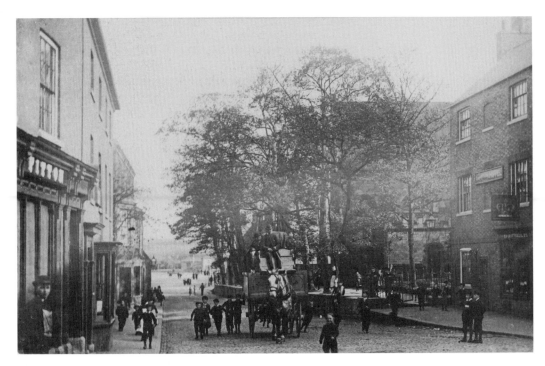

The Leicester bus obligingly doubles as the carrier's cart at the top of Burton Street. A block of houses on the left has gone but the Crown and the parish church provide an anchor of stability over the century or so since the original photograph was taken. The schoolchildren are missing but that is simply a matter of timing; by four o'clock they will be there again.

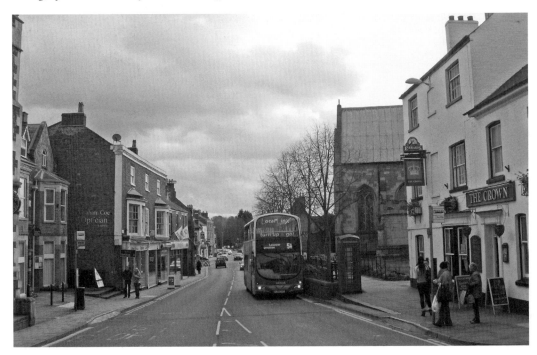

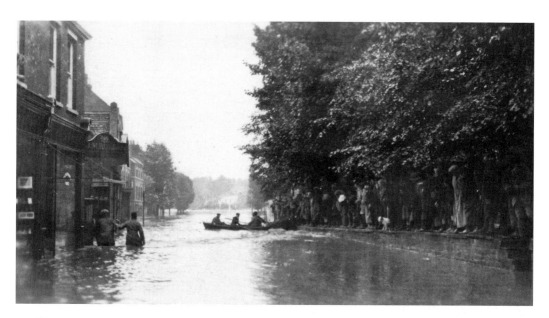

Sandbags have been a feature of many of Melton's streets of late but flooding from the River Eye is by no means a recent phenomenon. Here is the devastation of August Bank Holiday, 1922. Luxuriant trees and floodwater a couple of feet deep make these views of the upper part of Burton Street difficult to co-ordinate with its counterpart of 2012 but the windows behind the Yamaha flag and the churchyard wall (and steps) opposite are unchanged.

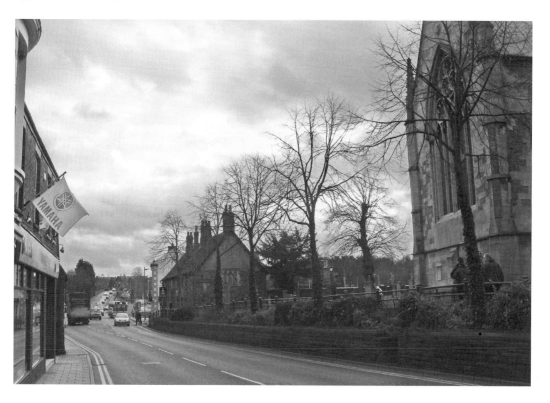

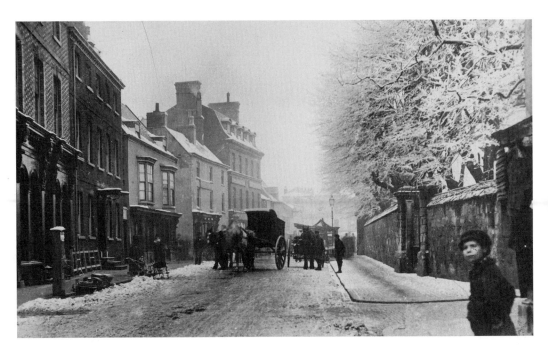

The contrast between the wintry Sherrard Street of the 1880s and that of January 2012 could hardly be greater. The Limes, the residence of Mr James Pacey JP, has vanished, giving way to a long 1930s building in concrete – with an ancient Egyptian motif. Opposite, the curious gables and dormer windows remain, as does the chequered brick above Bonmarché, though all between has been refaced or swept away to widen the turn into Burton Street.

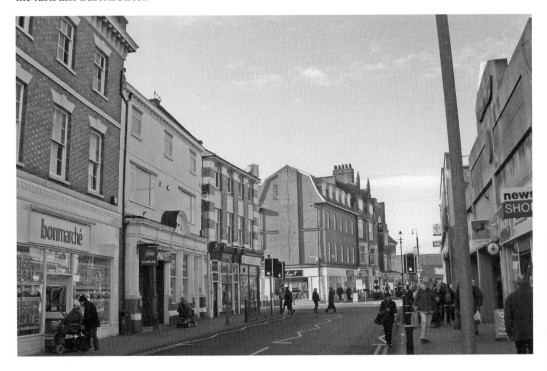

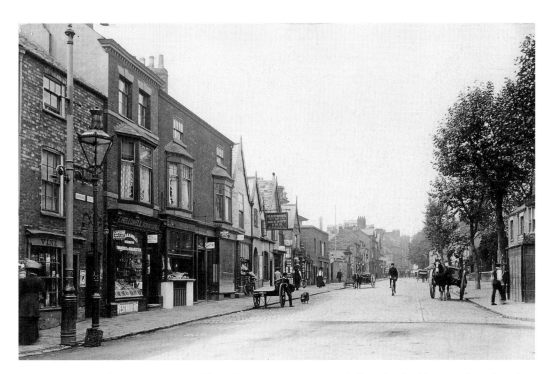

Although Sherrard Street retains an old-world character, surprisingly few of its buildings in this Edwardian view survive today. Heavy traffic makes it hazardous, to say the least, to replicate the earlier photographer's viewpoint in the middle of the road. The chimneys on the left help with orientation, as do the unusual gable seen in the previous photograph and the one surviving pointed roof (to the left of the traffic lights).

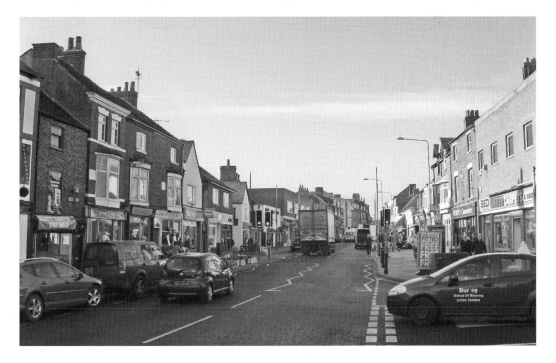

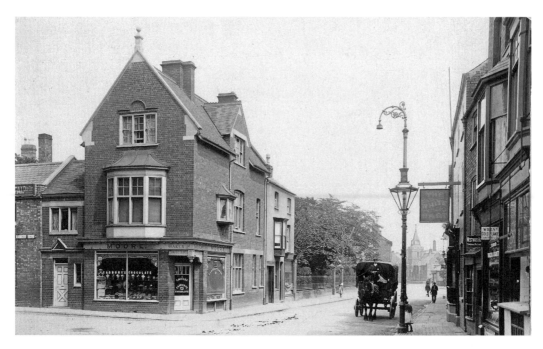

Whereas the bay windows to the right of these photographs of Sherrard Street's junction with Sage Cross Street once provided an appealing view of T. Moore's display of Cadbury's chocolates, they now command the plainer side of Morrison's store. Below them, a tobacconist has given way to a tattooist, while the White Hart has become a restaurant. Only the distant spire of the Carnegie Museum remains a fixed point.

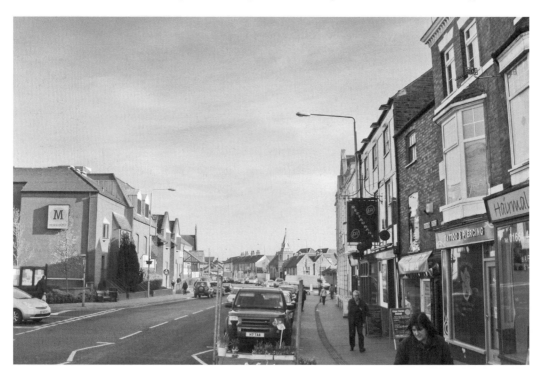

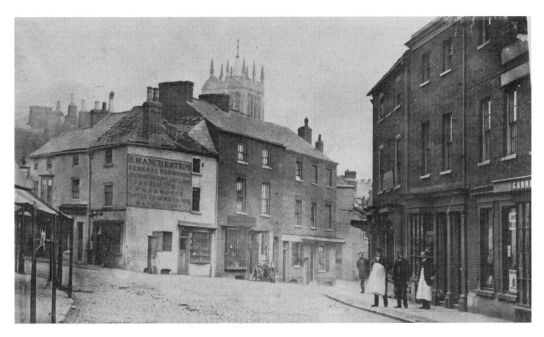

This early view of Cheapside, taken perhaps in the mid-1860s, is one of the hardest to match in modern Melton. Everything conspires against us! A tree obscures the church tower, while builders' barriers prevent a perfect viewpoint, and someone has built a Boots store across half the scene! Most surprising of all is that the Grapes is newer than it looks and has been built across half of Church Street. The key here – for the sharp-eyed – are the crenellations of the north aisle of the church, which peep out in both photographs.

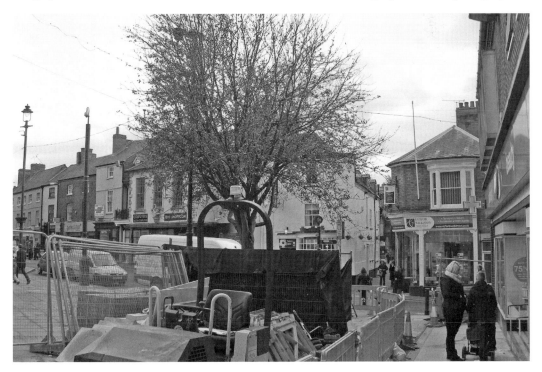

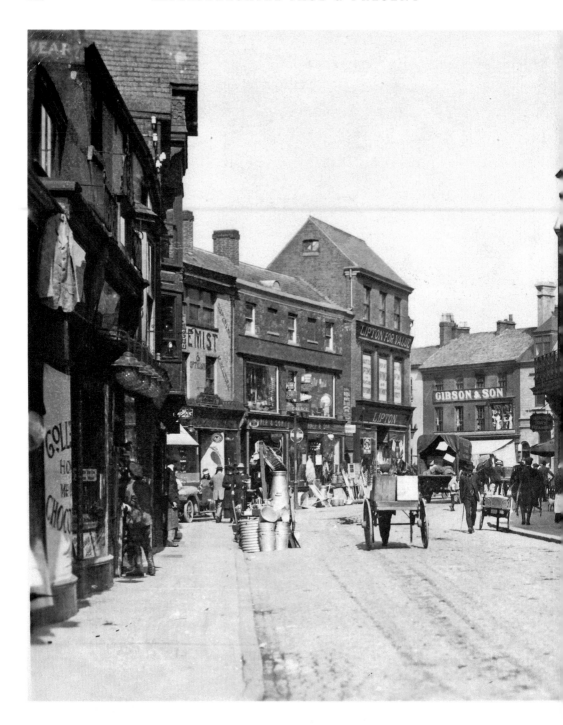

Turning the other way up Cheapside shows how little Melton has changed in a century. The Edwardian clutter of handcarts, churns and pails may have been replaced with a fast food stall and scaffolding, but the buildings themselves are readily identified. The decision to banish motor traffic can only be applauded here.

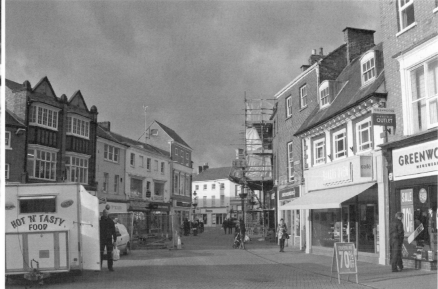

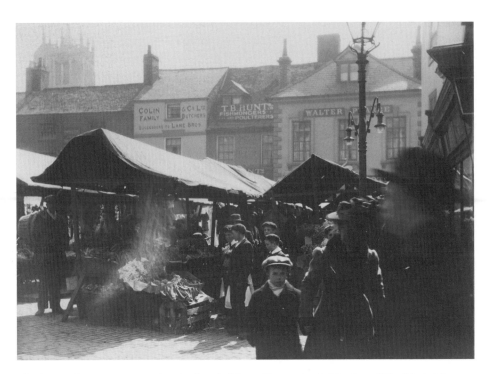

The famous Leicester watercolourist George Moore Henton took this view of the Market Square at 12.45 p.m. on 9 April 1912. Our view was taken at the same time, in January 2012. We too suffered from the low sun (which has slightly fogged his picture). The gold-dealer's trailer doubles for market stalls and by stepping back into King Street we have retained the impression of buildings closing in on the right; though in fact that whole block has been demolished. Little else has changed, even the swan (just visible in Henton's photograph) still occupies his nest between Melton Computers and the Tent Showroom.

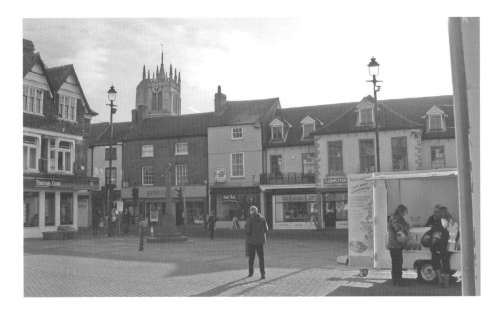

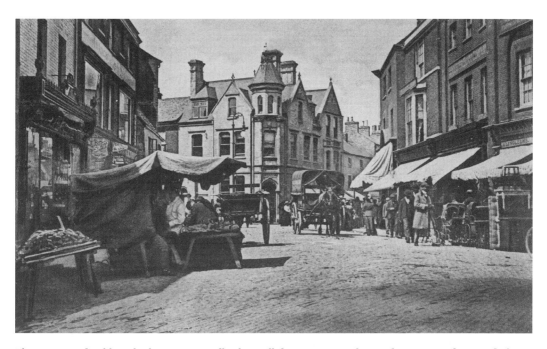

The turret and gables of what is now Ladbrokes still dominates South Parade. New windows and plastic façades do not hide the origins of most of this street's buildings at the turn of the nineteenth century.

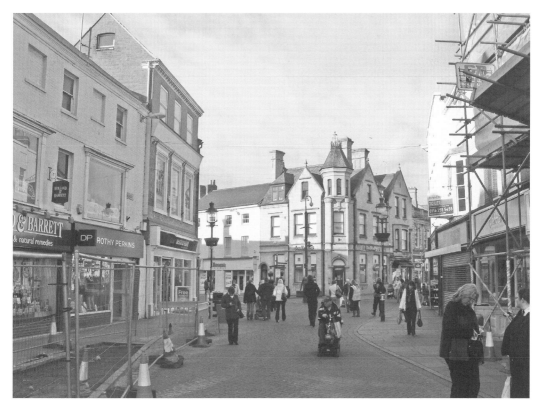

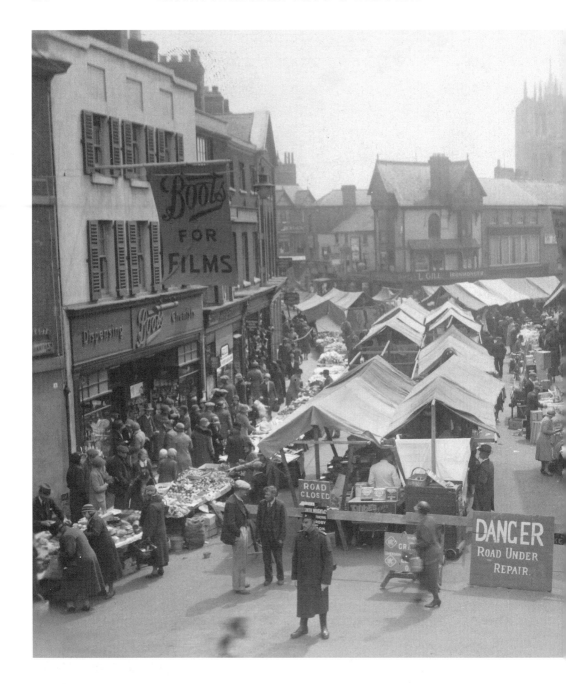

Two problems confronted us in trying to duplicate this view down South Parade towards the Market Place. The first is that the original view was clearly taken from an upper window of what is now Ladbrokes. Firmly rooted to terra firma we can only produce a different angle; which is obstructed by the cross erected by the Borough Council in 1996 and from which (in June that year) Her Majesty the Queen was presented with pork pie, stilton cheese and hunt cake. It is pleasing to note that the road was still up in 2012 – as it had been when first photographed in 1934.

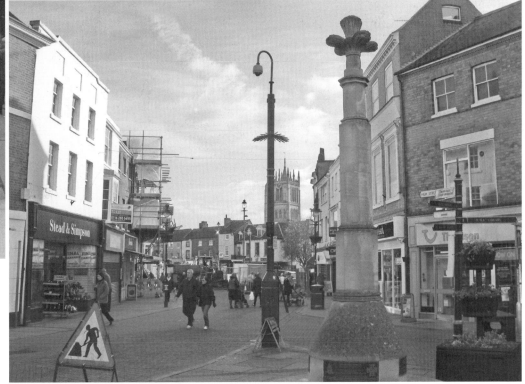

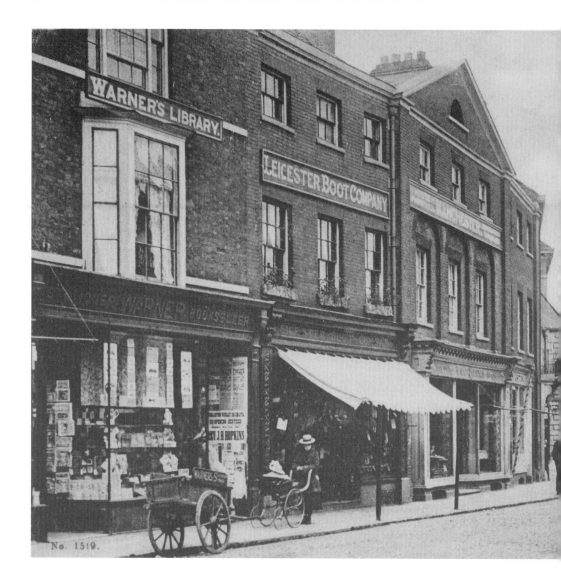

South Parade is easily recognised here, despite the camouflage of scaffolding and a few new shop fronts. The bay window of Warner's Library survives and Thornton's has obligingly pulled out its sunshade to follow the Leicester Boot Company's lead. The Market Place, revealed in 2012, is hidden in the view from a century earlier, by the large building which once occupied its entire western side.

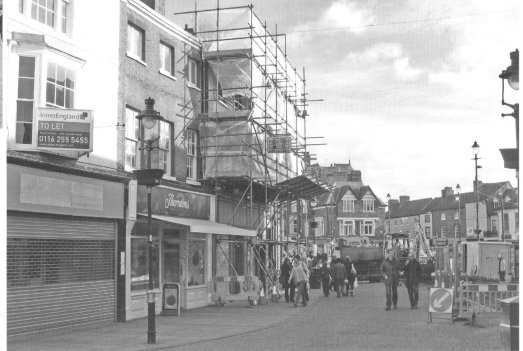

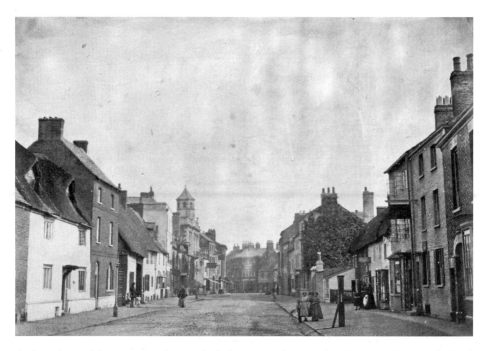

At first glance there seems nothing to link these two photographs. However, they are both of Nottingham Street, though separated by nearly a century and a half. The earlier view, taken perhaps in the late 1860s, shows a broad street, with several 'watering holes', including Mrs Adelaide Beeby's White Lion (whose sign is prominent below the corn exchange building on the left of the street). Close examination suggests that only one building has survived from Adelaide Beeby's day; the three-storey brick building, three doors up on the right. What do you think?

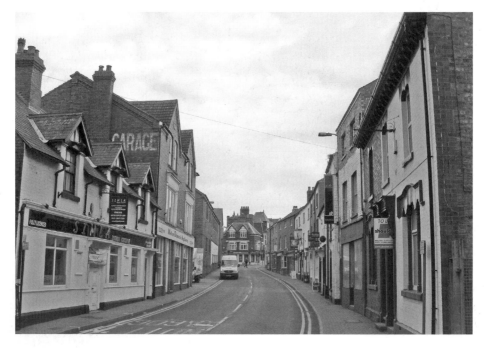